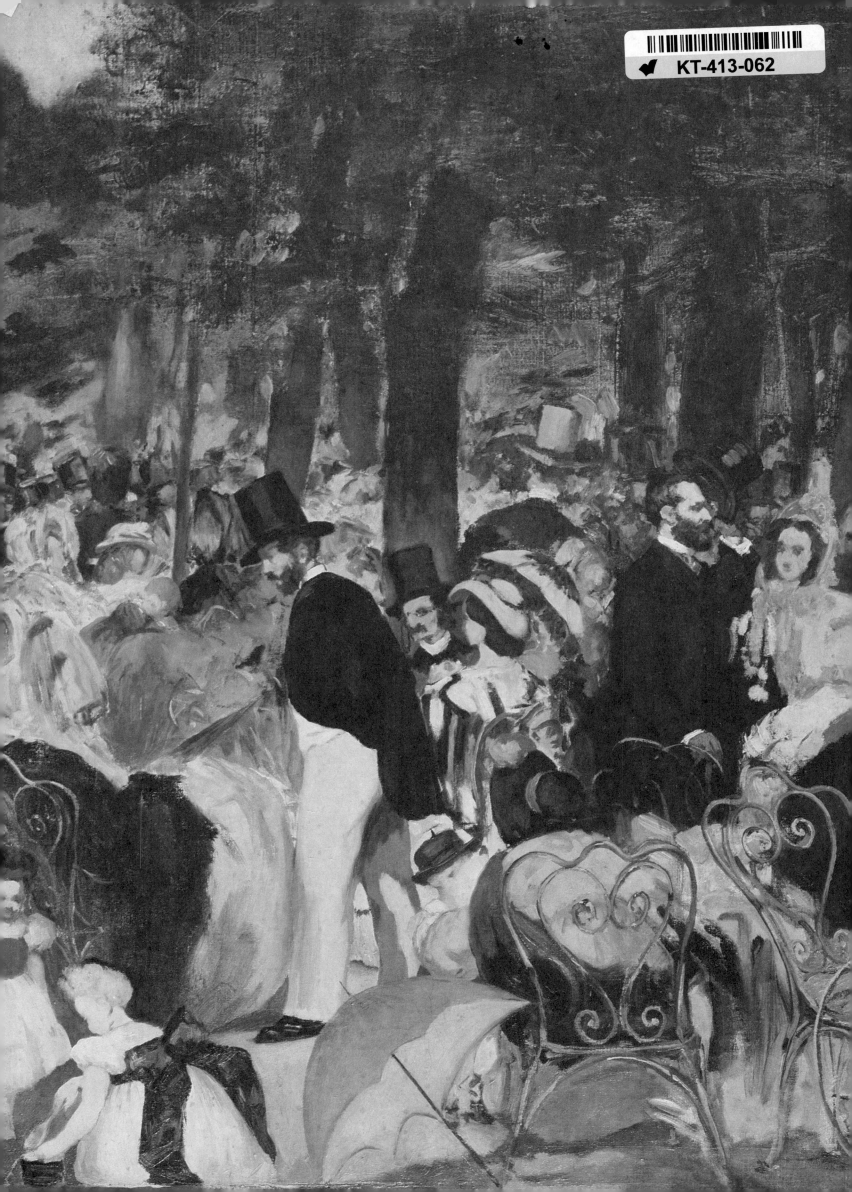

THE ART OF
MANET

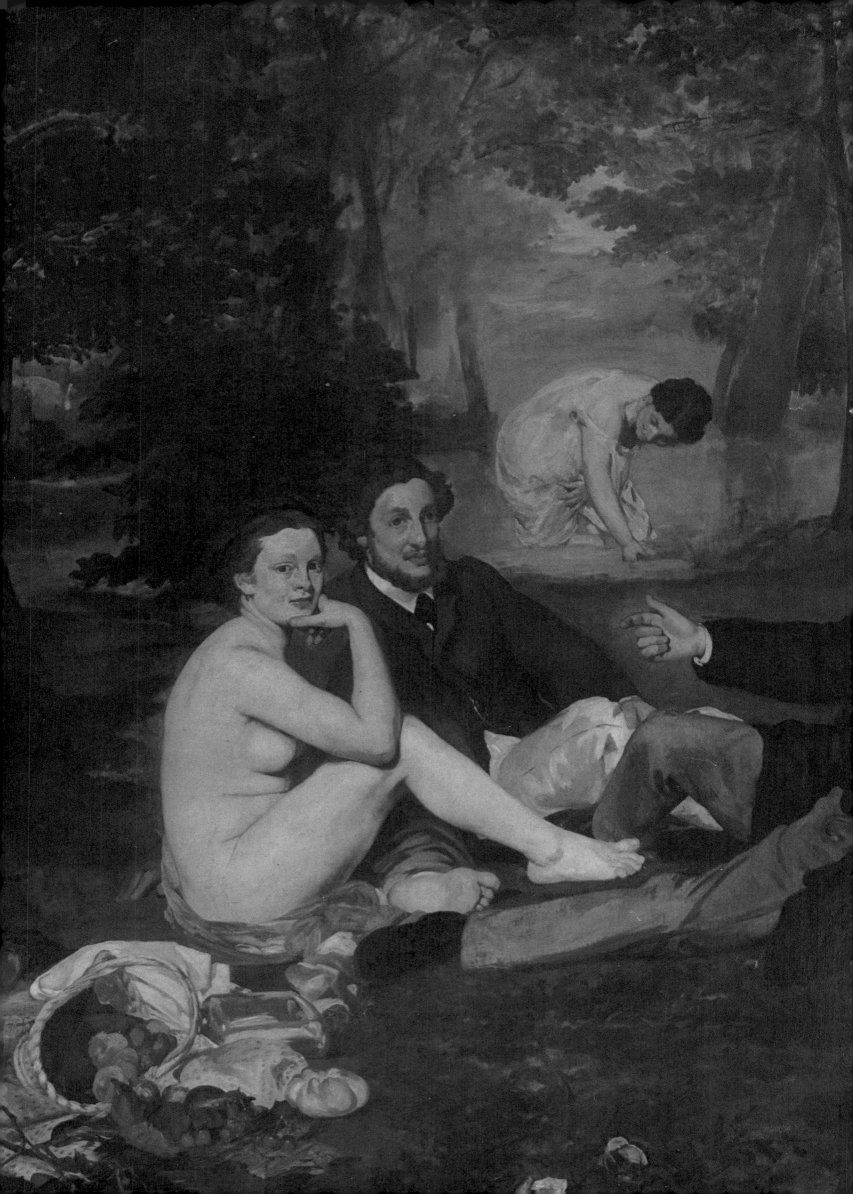

THE ART OF
MANET
Nathaniel Harris

Optimum Books

This edition published by Optimum Books 1982

Prepared by
The Hamlyn Publishing Group Limited
London·New York·Sydney·Toronto
Astronaut House, Feltham, Middlesex, England

Copyright © The Hamlyn Publishing Group Limited 1982
ISBN 0 600 37874 8

Printed in Italy

Contents

A Highly Respectable Rebel

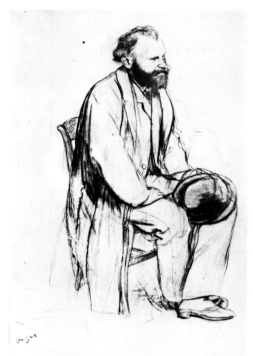

Edgar Degas. Portrait drawing of Edouard Manet.

Edouard Manet was a painter of genius and one of the heroes of 19th-century French art. His spontaneous approach to painting, summary style and use of bold contrasts and strong colours outraged the rule-bound artistic establishment of his time, but were experienced as liberating influences by the leading spirits of a younger generation. In an age when painting had become saturated with empty rhetoric and false sentiment, Manet pioneered a sophisticated modernity of subject and attitude, urban and urbane, and often light-hearted and casual. The modernity of his nudes, unforgivably alive and non-classical in paintings such as *Déjeuner sur l'Herbe* and *Olympia* (both 1862–63), caused some of the greatest scandals of the century, and ensured that Manet would be branded the arch-rebel of French painting for the rest of his life. Later still, he was associated with Claude Monet, Auguste Renoir and the other Impressionist painters who, by the 1870s, were creating dazzling, unconventional outdoor scenes that both the public and critics found incompetent and ludicrous. The inevitable result of these sins against received ideas was that Manet failed to achieve popular or critical success; even the most limited kind of recognition was denied him until the last year or two of a life that ended prematurely in April 1883.

Such a tale of misunderstood genius is hardly uncommon in the 19th-century record, for many other painters suffered in comparable ways. Monet was at one time so discouraged and poverty-stricken that he tried to drown himself; Cézanne, ridiculed as a kind of wild man of painting, deliberately retreated into obscurity; and Vincent van Gogh's fate was perhaps the hardest of all, since he endured years of terrible poverty, isolation and mental disturbance, and was still virtually unknown when he took his own life at the age of thirty-seven. What makes Manet's case unusual is that he was a conformist by temperament and upbringing; he had no desire to shock the public, and seems to have been only intermittently aware that he was an innovator. There was nothing of the bohemian outsider in his make-up. He was born into the upper middle-class, and always behaved as a gentleman, dressed as a gentleman and exhibited a gentleman's taste for social approval. In fact, he longed for conventional success, and fully intended to please the public by his work. Year after year he submitted it to the official state exhibition, the Salon, despite responses that, for the most part, alternated between tepid interest and explosions of outrage. Every rejection hurt and bewildered him, but also spurred him on. He never openly rebelled, for he remained convinced that 'the Salon is the real field of battle', and when the opportunity presented itself, he refused to join his younger friends in breaking with the system and forming an independent exhibiting society. Thus the first Impressionist exhibition of 1874 – another great 19th-century scandal – took place without Manet's participation. In the event, it appeared that he had conformed in vain, for most of the critics nevertheless regarded the Impressionists as 'Manet's gang' and blamed him for the horrors the 'gang' were said to be perpetrating. In spite of this, Manet doggedly pursued his own chosen course at the Salon; and he was ultimately rewarded – with a second-class medal.

Remarkably, Manet's gifts as an artist were not to be significantly corrupted by the pressure of his ambition. His touch was by no means always certain – he is perhaps the most uneven of the major 19th-century French painters – but the uncertainties seem to derive from the struggle to free himself from stereotypes rather than from submission to them. Occasionally he did choose a subject and treatment that he hoped would be acceptable to prevailing tastes, notably the quasi-Dutch *Le Bon Bock*, an innocuous portrayal of the traditional 'merry toper' which found favour at the Salon of 1873; but such instances were exceptional in the art of his maturity – almost in spite of himself. Some of his friends later remembered times when he began a portrait with the firm intention of achieving the 'chocolate box' sweetness requisite to popularity, only to scrape

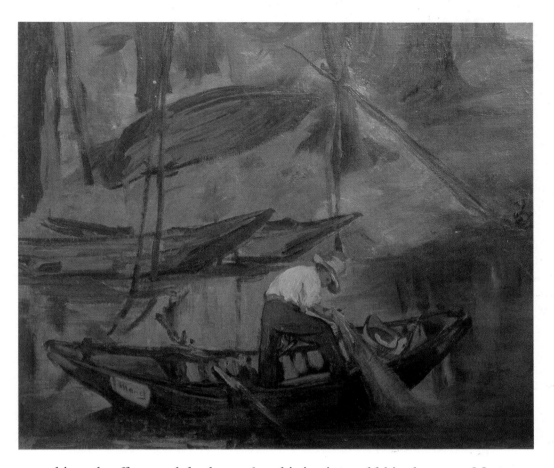

Fishing. c. 1861. A study for the background of Manet's famous *Déjeuner sur l'Herbe* (page 24). Museum von der Heydt, Wuppertal.

away his early efforts and do the work as his instinct told him he must. Manet is thus a fascinating example of a respectable man in whom the artistic impulse is embarrassing and irresistible, transforming him into a rebel despite all his social training and his deepest convictions.

Edouard Manet was born on 23 January 1832 at the Rue des Petits-Augustins in Paris. He was the eldest child of Auguste Manet, then thirty-five, and his twenty-one-year old wife Eugénie, who was to have two more sons in quick succession. These two, Eugène and Gustave Manet, became civil servants like their father; Edouard proved to be the odd man out in the family, perhaps influenced by his mother's artistic (although mainly musical) leanings and her less staid family background.

Auguste Manet was already the head of a department at the Ministry of Justice when his son was born, and he ended his career as a judge. The prestige attached to the judiciary was particularly strong in France, where there had been a judicial nobility (*noblesse de la robe*) until the revolution of 1789, and the Manets were placed right at the upper end of the French upper middle class. They were wealthy too, and Edouard Manet, unlike the majority of his distinguished contemporaries, was never to have any serious money worries. He was therefore in the peculiar position of being able to withstand any amount of establishment disapproval in material terms, while finding it intensely uncomfortable from a social and temperamental point of view.

Auguste Manet appears to have been a stern father in the Victorian tradition, determined to mould his children in his own image. Our rather joyless impression of him is confirmed in Manet's *Portrait of the Artist's Parents* (1860), in which there is not the slightest suggestion of frivolity or opulence or self-indulgence; in fact one contemporary critic remarked that the couple might have been a caretaker and his wife. By contrast, the painter-to-be Edouard Manet was described as 'frivolous' in his school reports from the Collège Rollin, and in adult life he was, if not quite a dandy, very much the elegant, apparently care-free man-about-town (contemporaries used the evocative term *flâneur*, literally 'stroller'). Although Manet remained a dutiful son, his lifestyle was an implicit rejection of his father's values – as, indeed, was his art.

Manet's first serious introduction to his future profession occurred at the Collège Rollin, where he received drawing lessons; according to one account, they were an optional extra that his father refused to pay for but which his uncle, Edmond Fournier, agreed to finance. Apart from gymnastics, these lessons were the only ones that seriously interested Manet, and his poor showing

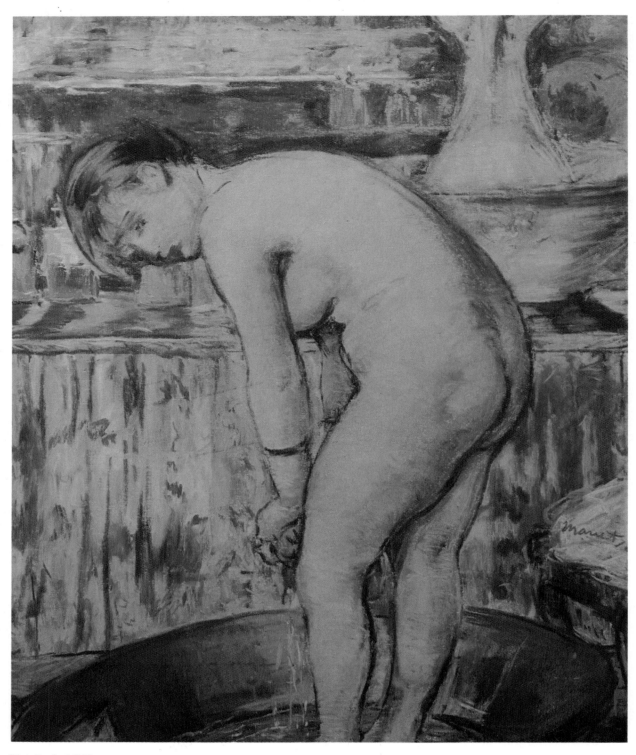

The Bath. 1878.
Musée du Louvre,
Paris.

at school may have persuaded Auguste Manet that Edouard would never succeed in the legal career that had been planned for him. At any rate he consented when his son claimed to feel a vocation of another sort – not for painting, but for the sea; in France, as elsewhere, a naval or military career – as an officer, of course – was quite acceptable for a boy of good family, and especially if he was none too bright.

In July 1848 Manet sat an entrance examination for naval college but was rejected. At the time, applicants were only allowed a second chance if they first made a six-month-long voyage in a French ship, and therefore, in December 1848, Manet signed on as a cadet with the *Le Havre et Guadeloupe*, sailing for Rio de Janeiro; already clothes-conscious, he noted in a letter to his mother that he had been allowed to wear standard naval rig, consisting of a waxed hat, flannelette undershirt and canvas blouse and trousers. On reaching Rio, he observed that the city had a certain charm for someone like him ('a European with artistic leanings'), although he found the spectacle of Negro slavery revolting; and it was perhaps in Rio that he acquired the taste for the exotic that appears from time to time in his work. The voyage itself seems to have been uneventful, but Manet later claimed that it was important as the occasion of

his first painting commission: he was told to touch up the red rinds of some Dutch cheeses, carried as cargo, which had become rather battered by the motion of the ship.

Having qualified by service, Manet re-sat the examination, but failed a second time. Since a naval career was now out of the question, his father agreed that he should study painting with a respectable master – agreed, we should imagine, for want of a better alternative. Did Manet fail his naval college examinations deliberately? It is tempting to suppose so, since his failure was probably more effective in getting him what he wanted than open rebellion would have been; like other young men of his class and time, Manet had been brought up to obey his parents and was in any case financially dependent on them to an extent that is now difficult to imagine. Interestingly enough, the pattern of 'official' failure and real advance, initiated here, was to be characteristic of Manet's entire career.

From Auguste Manet's point of view, his son's choice was hardly suitable for the scion of a civil service family, but it was by no means disgraceful. True, the world of art had its bohemian element, but there also existed a perfectly respectable career structure in which a young man might take his place and move upwards, with something approaching the predictable regularity of civil service life. The official system was, in fact, thoroughly bureaucratic, largely controlling an artist's working life from his student days until the moment when he was decorated with the Légion d'Honneur and became one of the dignitaries who supervised a new generation from the heights of the Academy of Fine Arts. In these circumstances, an approved 'academic' art became the norm, since the Academy could make or break careers by the awarding or withholding of prizes to students, and of medals and 'mentions' to practising painters. Furthermore, an official show, the Salon, was held every two years in Paris (annually from 1863), first at the Louvre and later at the Palais d'Industrie; and since this was

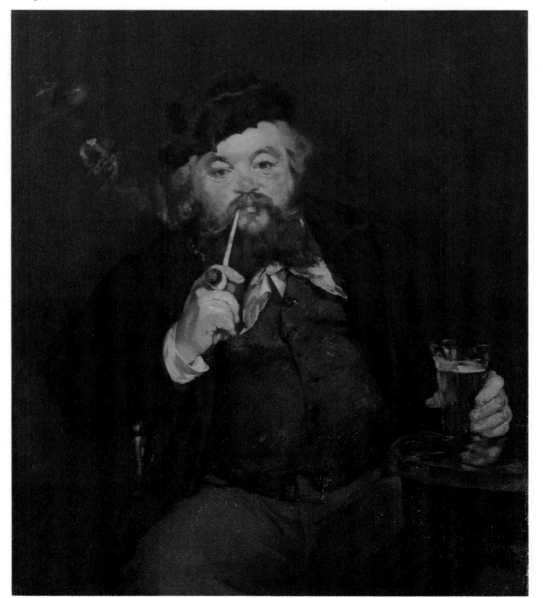

Le Bon Bock. 1873. One of the few works by Manet to achieve popularity in his own lifetime. Both subject and treatment were relatively conventional, although Manet did not entirely restrain his taste for strong colour. Philadelphia Museum of Art, Mr. and Mrs. Carroll S. Tyson Collection.

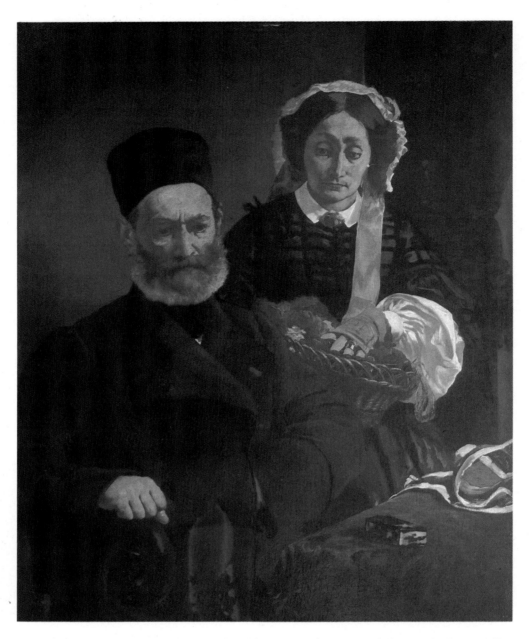

virtually the only channel through which a man's work might reach the public, it reinforced the power of the Academy over all artists. The public itself generally took its opinions from the Academy, just as the Academy took its morals from the public, with the result that both the content and treatment of works of art were severely restricted. Similar situations in other countries produced the widespread phenomenon of a 19th-century 'academic art' that applied great technical accomplishment to the manufacture of stereotypes, substituting an empty 'nobility' and pseudo-classicism for truth, and preferring sentimentality to reality.

The 'nobility' and classical attitudes were mainly reserved for history painting, which carried enormous prestige; it allowed the artist to work on the grand scale, to achieve merit (in a work-oriented society) by painstaking research into his subject, and to strike attitudes and draw morals without the slightest risk of becoming involved in controversy. The painter of history or myth could also introduce into his work a note of eroticism that was prohibited in every other area of public life; and as a result the 19th-century galleries of museums are filled with blatantly sexy paintings which, to modern eyes, acquire an unintended absurdity through their thin historical or mythical trappings. (For example, a queue of girls who are stark naked – in readiness, it seems, to have their ankle-sprains and arm-bruises examined by the doctor-god Aesculapius – brings to mind some very ancient jokes about the medical profession.) In this 'Victorian' age of prudery, the nude was acceptable in art provided she was 'antique', and she might be ultra-seductive provided certain realities remained unobserved (body hair, for example, or the all-too-real uneven surface of actual flesh). A contemporary nude, even if depicted as less erotic than her antique counterparts, was likely to be found shocking, since she would suggest real sex in the real (and

therefore somehow 'vulgar' and 'coarse') world – a fact that Manet was later to learn in painful circumstances.

The painter who aspired to the 'grand style' was a conscious anti-realist who believed that it was right to idealize his subjects; Claude Monet's teacher told him in all seriousness that one could not paint the big toe of the Roman hero Germanicus in the same way as one would paint the big toe of a coalman. Idealization does not necessarily produce bad art, of course, but that was its effect in the 19th century because there was no real conviction behind it: an artist painted in the grand style because he was ambitious, casting about for some historical or mythical episode that might hold no genuine interest for him but would cause a sensation because it had never been tackled before. The outcome was lifeless work, mechanically executed in a slick technique which rarely displayed the slightest originality or individuality. The ambitious history painting, supreme in its own time, has long been the least regarded of 19th-century genres, which even the intense nostalgia of our own period can never revive except in a spirit of fun, whereas landscapes and standard 19th-century scenes of contemporary life – although often over-idealized or sentimentalized – can at least command a certain interest.

The great and growing popularity of landscapes reflected a new general sensibility, passionately responsive to nature, that had developed with Romanticism; but it also reflected the fact that this 'minor' genre could be approached with a freshness and sincerity for which there was no place in the 'major' genre of history painting. And because landscape continued to be regarded as minor, there was relatively little destructive criticism of the outstanding landscapists of

Vase of Peonies on a Pedestal. 1864. Musée du Louvre, Paris.

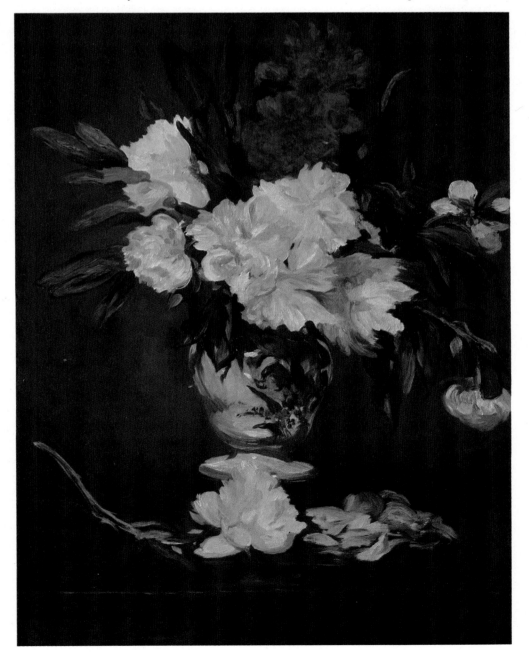

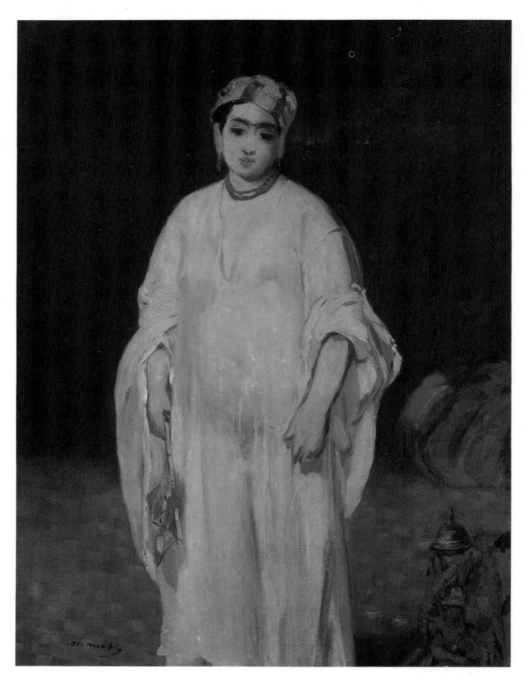

The Sultana.
c. 1875? This
painting of a young
woman in 'oriental'
dress is one of
Manet's more
fanciful productions.
Bührle Collection,
Zurich.

the early and mid-19th century, such as Camille Corot and the 'Barbizon school' – Théodore Rousseau, Jean-François Millet, Charles-François Daubigny and others.

The only open rebellion against academic standards before Manet's time was launched by Gustave Courbet, a roaring bull of a man who declared himself a Socialist and a Realist, and shocked polite society with his huge *Burial at Ornans* (1850). The painting was realistically observed – the participants are variously bored, distracted, perfunctory and grief-stricken, not uniformly sorrowful in conventional fashion; but Courbet's greatest offence here was the scale and seriousness with which he treated the lives and deaths of common men, giving them an heroic dignity that exasperated their 'betters'. However, his Realism – actually rather intermittent – was mainly devoted to the almost unchanging life of the peasantry; unlike Manet, he was not a painter of the specifically modern and urban, let alone of fashionable society. Understandably, the two men never became friendly: one cannot imagine the elegant Manet as the companion of Courbet, that gargantuan, gourmandizing, pipe-smoking, ranting denizen of the beer halls. And Courbet, the limelight-loving rebel of the 1850s, almost certainly resented the fact that he was supplanted in public disfavour by Manet during the 1860s. Furthermore, the scandals caused by Manet's work were vastly greater than any earlier controversies over Courbet; however much they disliked his social attitudes, critics and public alike recognized that Courbet was a technically superb painter, whereas Manet's innovations struck at deeper prejudices concerning both art and sexual morality, and were therefore

attacked with frenzy as either incompetent or degenerate. Ironically, from everything we know of Manet he would gladly have given Courbet every particle of his future notoriety.

Such, then, was the art world at the time (1850) when Manet entered the studio of Thomas Couture as a pupil: the occasional rebel appeared, but the rule of the Academy remained unshaken, and the public applauded its laws. And so it remained, albeit with modifications, for another fifty years or more, with the result that almost all the great art of the 19th century (and the arts flourished mightily during that century, especially in France) was produced by rebels and 'failures' in the face of a hostile public opinion, disapproving teachers and scathing critics.

Couture was a famous man, and it may well have been Auguste Manet who determined that Edouard should enter his studio. Only three years earlier, Couture had exhibited his *Romans of the Decadence* to near-universal acclaim. In this large canvas, half-clothed Romans, their limbs entangled, loll about in orgiastic exhaustion amid stern statues of their virtuous ancestors, while a philosopher and a poet look on, frowning their disapproval; and no doubt there are unseen barbarians at the gates of the city, about to march in and set up a régime of brutal health. For some years this picture was considered one of the masterpieces of the century, and it does in fact exemplify the qualities we should expect to find in a popularly successful history painting: it is carefully painted, accurate in details although lacking all real historical feeling, and is imposingly pseudo-serious; only the sexual emotion, albeit restrained, carries much actual conviction. Technically, Couture was a highly skilled artist, and his less ambitious paintings – for example his portraits – are of some interest, but he and his contemporaries believed *The Romans of the Decadence* to be of far greater importance, and expected that posterity would judge him by it; and posterity has done so.

It was hardly to be expected that Manet would be happy in Couture's studio, and such evidence as there is for this period of his life suggests that he was not. Our chief witness is Manet's life-long friend Antonin Proust, who had met the painter when they were pupils together at the Collège Rollin; like Manet, Proust studied under Couture, but he later elected to make a more worldly career, and eventually became an influential politician – in which capacity he was able to be of some service to his old friend. Proust published his recollections of Manet thirty years after the painter's death, and much of what he writes seems a little too good to be true – or, at any rate, too neatly in line with Manet's later opinions and reputation. However, with the qualification that some of it may contain an element of hindsight, Proust's version of Manet's time at Couture's is worth repeating in condensed form.

As remembered by Proust, the young Manet was already keenly interested in the life about him and impatient of the artificiality that was inevitable in studio work. He would grumble, 'I don't know why I'm here. Everything we see here is

Gustave Courbet. *Burial at Ornans.* 1850. Though technically a traditionalist, Courbet outraged contemporary opinion by tackling 'low' subjects, such as this one, in a spirit of high seriousness. Manet gave comparable attention to the more sophisticated life of the city. Musée du Louvre, Paris.

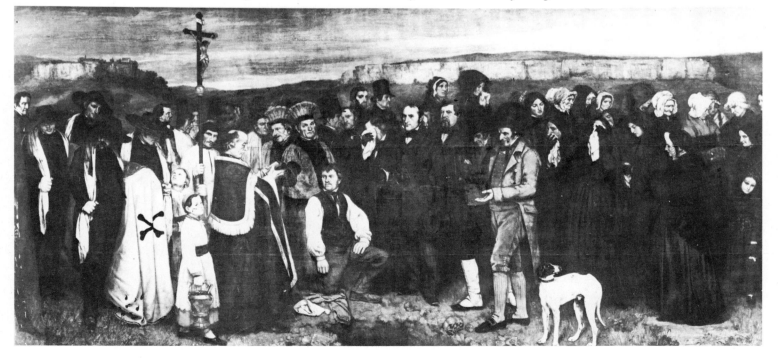

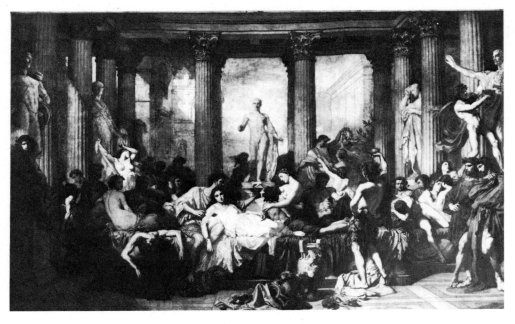

Thomas Couture.
*The Romans of the
Decadence.* 1847.
Couture's contem-
poraries believed
this to be one of the
great paintings of
their time — in fact
it exemplifies the
pretentious emp-
tiness of the 'grand
style' they admired.
Subsequently,
Couture's role as
Manet's teacher has
probably been
underestimated.
Musée du Louvre,
Paris.

absurd; the light's false and the shadows are false. When I get to the studio I feel as though I'm entering a tomb.' He clashed with Couture, and also with the models whom Couture provided. These were professionals, often well known and with long experience of their work, who had given satisfaction by their ability to sustain solemn and exaggeratedly 'heroic' poses. When an opinionated young man told them to stand more naturally, or remarked that the model's attitude was not one he would adopt to buy a bunch of radishes, the professionals were understandably put out. One of them loftily reminded Manet that, thanks to the heroic attitudes he had struck, more than one student had gone to Rome – that is, had won the coveted Rome Prize, which brought with it a period of subsidized study in the Italian capital. But Manet only snapped back: 'We're not in Rome now, and we don't want to go there! We're in Paris: let's stay where we are!' In a confrontation of this sort, between old and new ways, it is possible to feel sympathy for the bewilderment of those who lived by the old: one can imagine the incomprehension of the model when confronted with a young man who wanted to bring radishes into the sacred grove of Art, and appeared to despise in equal measure the Eternal City and the Eternal Verities.

Wishing to draw a clothed model was another of Manet's heresies. The academic tradition concentrated on the nude, insisting on the most painstakingly detailed rendition of bone structure and musculature – a training of some value, although hardly an end in itself. When Manet did persuade a model to wear some clothes, Couture walked in and put an end to the proceedings, furious at what he considered to be a waste of money. After Manet confessed that he was respon-sible, Couture remarked pityingly, 'My poor boy, you will never become any-thing more than the Daumier of your day.' Since Couture is now virtually forgotten, while Daumier, with his ferocious caricatures, political passion and energetic social realism, ranks among the 19th-century masters, further comment seems unnecessary.

The fact remains that Manet spent six years at Couture's – an extremely long period by any reckoning. It is possible, of course, that he stayed on because his father (who held the purse strings) insisted on it, or because Manet's instinct for 'the done thing' made him determined to stick to a conventional course of study. But it seems more likely that Proust's memory played him false, endowing Manet with precocious convictions that perhaps developed only in his last few months with Couture. Furthermore, life at a studio was mostly a matter of routine, not confrontation. Students worked by themselves from the model, visited only twice a week by Couture, who seems not to have been the most energetic of teachers. 'He glanced at our studies with a distracted eye,' recalled the admittedly hostile Proust, 'ordered a break, rolled himself a cigarette, told some stories about his master, Gros [a famous painter of Napoleonic battle scenes], and then took himself off.' Like others before and since, Manet may well have found that a student's life in an easy-going institution had a great deal in its favour.

Not that he avoided hard work: after a day at Couture's he often spent the evening at the Académie Suisse, which was not in fact a teaching institution but

a studio where, for a small fee, artists could work from a model without supervision. (The Suisse had a long history, and was frequented by many later dissenters from the established system, including Monet, Pissarro and Cézanne.) Like other students he spent a good deal of time at the Louvre in Paris, which was already a treasure-house of European art; most of Manet's earliest surviving canvases are copies of masterworks in the museum, notably of the great Venetians, Titian and Tintoretto. And after leaving Couture's in the spring of 1856, he spent much of the next two years in Belgium, Holland, Germany and Italy, examining and copying paintings such as Rembrandt's *Anatomy Lesson of Dr. Tulp* and Titian's *Venus of Urbino*.

Copying was – and had long been – standard practice, useful to both artists and patrons. A faithful copy could be a source of pleasure and instruction for those who were unable to see the original, functioning in much the same way as a modern colour reproduction; impecunious artists often earned a living by making such copies. (One of their number was Henri Fantin-Latour, a young man whom Manet met in the Louvre; he later became a famous flower painter, and a group portraitist whose works included the *Homage to Manet* of 1870.) Manet had no need to scrape a living in such a fashion, but he probably benefited from another feature of copying – that it taught the student a certain amount by involving him in a simulation of the creative process. A close acquaintance with the great works of the past must also have strengthened Manet's resolve to create an equally significant art for his own time. The academic tradition represented a synthesis of those elements in the art of the past that could, so to speak, be tamed and shown off without the slightest risk of disturbing the spectator; Couture, for example, was regarded as the heir to the 16th-century Venetian painters, even employing Venetian techniques, and yet he produced finished work that was clearly in the academic mainstream. Direct study of the past revealed the true variety of its art and was therefore – an apparent paradox – an encouragement to revolt in the present; it was no accident that many 19th-century rebels were, like Van Gogh, life-long copyists, and believed with Cézanne that 'The Louvre is the book in which we learn to read.' In Manet's case the past was particularly important, since many of his own paintings had a more or less direct relationship with earlier artists' works, either borrowing from them and/or gaining extra richness by pointed allusions to them. The most famous example of all was to be Manet's *Olympia*, which was to be the result of a fascinating and complex relationship with the *Venus of Urbino* that he admired and copied at Florence in 1856.

In 1858–59, back in Paris, Manet painted *The Absinthe Drinker*, the first picture he thought good enough to submit to the hanging committee for the Salon. In effect, his professional career had begun.

Honoré Daumier. *Gargantua*. 1832. Irritated by Manet's taste for reality, his teacher once told him he would never amount to anything but a . . . Daumier. The intended insult would now be seen as a compliment, although Manet's 'realism' actually has little in common with Daumier's ferocity, social commitment and talent for caricature, all of them in evidence here. Bibliothèque-Nationale, Paris.

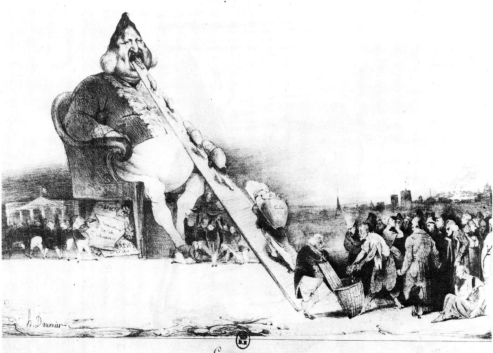

Gargantua

Painter in Paris

By 1859 Paris had become a glittering showpiece capital for the glittering Second Empire ruled by Louis-Napoleon Bonaparte, the Emperor Napoleon III. Earlier, the French Revolution and Napoleonic era (1789–1815) had divided Frenchmen into fundamentally opposed political groups; by Manet's day these included royalists of two different complexions as well as republicans and Bonapartists. In 1848 the last French king, Louis-Philippe, had been overthrown, to the evident satisfaction of the Manet family, who were staunch republicans. But the first elected president of the new republic was Louis-Napoleon, nephew of the great emperor who had made France supreme in Europe for over a decade at the beginning of the century. People like the Manets had little faith in Louis-Napoleon's republican professions, and on board the *Le Havre et Guadeloupe* Edouard had written to his father, 'Try to keep a good republic for us against our return; I'm afraid Louis-Napoleon is not a very good republican.'

Manet was proved right, although it was not until 2 December 1851 that Louis-Napoleon staged the *coup d'état* that gave him absolute power and paved the way for the revival of the Empire in the following year. By 1851 Manet was serving his time at Couture's, and on the day of the *coup* he and Antonin Proust were foolhardy enough to leave the studio in order to see what was happening in the streets; according to Proust, they narrowly avoided being trampled by a cavalry charge and, after witnessing some of the fighting, were taken into custody and escorted to places of safety. Later, they and other young men from Couture's visited the Montmartre cemetery where the dead republicans were laid out; the sight of relatives filing past in mournful silence, punctuated by occasional shrieks of appalled recognition, made a terrible impression on even the carefree students.

Manet remained a republican by conviction, although politics had only a very limited place in his life or art (despite touchy reactions to some of his work on the part of the authorities); but he was necessarily a man of the Empire, since the society in which he lived was influenced in some vital aspects by the Emperor and his régime. The reign of Napoleon III (1852–70) was notable for incoherent military adventures and diplomatic manoeuvres, and also for an industrial and commercial expansion that enriched the middle and upper classes. In particular,

E. Guerard. *The Boulevard des Italiens*. 1856. Modern Paris, the city of the great boulevards, was being created during Manet's twenties and thirties under the Second Empire of Napoleon III. Musée Carnavalet, Paris.

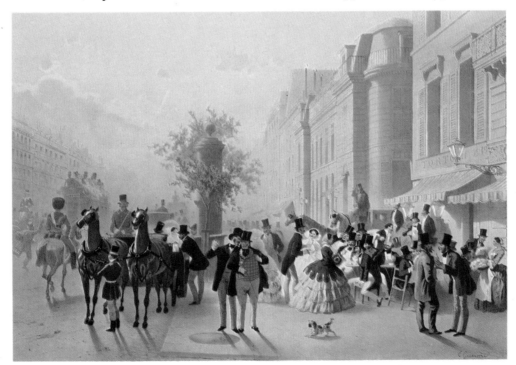

its effect was to transform Paris, for the city was run by an energetic Prefect, Baron Haussmann, who carried out a gigantic scheme of demolition and re-building. 'Haussmannizing' effectively created modern Paris; it was Haussmann who drove wide new streets – the boulevards – through the capital, created the great parks, built the great central market, Les Halles, and laid out the first proper system of sewers. There was a far less admirable side to the process (tasteless, financially shady, socially exploitative), as there was in everything to do with the Empire; but it is less relevant here, since Manet and his circle never sought to penetrate the slums that lay behind the boulevards, or to 'expose' social conditions except in the sense that the rather gamey morals of the time are implicitly revealed in some paintings. For a broader view of Parisian society we must go to the novels of Emile Zola, who was also, incidentally, Manet's chief supporter among art critics. Through paintings, Second Empire Paris is known to us above all as the city of elegant carriages in the Bois de Boulogne, of famous courtesans and great actresses, of the *flâneur*, the terrace café, cabarets and dance-halls, the circus, riverside pleasures and regattas. In other words, it is essentially the city of the Belle Epoque, that golden age – as it seems in folk memory – that survived the fall of the Empire and only came to an end with the World War of 1914–18. But for the 'modernity' of Manet and those like him, so repugnant to contemporaries, our image of their time would be sadly faded and monochromatic.

Manet himself may have begun his career with the intention of making forceful statements about society at large; for a year or two, at least, poor people figured significantly in his work, after which he gave most of his attention to more elegant bourgeois subjects. In *The Absinthe Drinker* he portrayed an alcoholic rag-picker named Collardet who was well known to artists because he plied his trade around the Louvre. This picture is as close as Manet ever came to overt moralizing and social comment; the man is bleary and blurred, while the absinthe glass is sparkling-clear, hovering beside him like an unholy grail. But in painting style the work is already characteristic of Manet, despite large debts to Couture: he was beginning to dispense with detail that the eye did not take in, and was achieving a new boldness and clarity by eliminating the graduated tones essential to academic smoothness of effect. These techniques may explain the rejection of the painting by the 1859 Salon hanging committee; only Eugène Delacroix, the great Romantic painter of an earlier generation, is said to have voted for its inclusion in the show. Although the morality of *The Absinthe Drinker* seems sound enough from a 19th-century point of view, the evidently squalid condition of the rag-picker in his stove-pipe hat may have seemed a little too convincing for contemporary tastes. It has also been suggested that the picture gave offence because it appeared to refer to a poem by the scandalous Charles Baudelaire, who was prosecuted for his *Flowers of Evil* (*Les Fleurs de Mal*, 1857), which subsequently had to be expurgated. All the same, it is difficult now to understand why *The Absinthe Drinker* should have caused any great fuss, and especially why Thomas Couture, Manet's former teacher, should have been so incensed by it as to sneer that the artist was the real drunkard in the case – a remark that inevitably caused the final break between the two men.

It is almost as difficult to understand the extremely favourable reaction that greeted Manet's next submission to the Salon, in 1861. Both the *Portrait of the Artist's Parents* and *The Spanish Singer* (also known as *The Spanish Guitarist*) were accepted for exhibition, and *The Spanish Singer* enjoyed a considerable success. Manet could not know it, but this was to be one of the few occasions on which he would please almost everybody with his work. *The Spanish Singer* was awarded an Honourable Mention at the Salon; a group of young painters and writers were so impressed by it that they paid a ceremonial visit of congratulation to the painter in his studio; and the veteran Romantic poet and critic, Théophile Gautier, praised Manet's vigorous brush-work, true colour and strict realism ('*Caramba*! Here we have a *guitarrero* who doesn't come from the Opéra Comique . . .'). To modern eyes, Gautier's enthusiasm appears excessive: *The Spanish Singer* now seems awkwardly posed and picturesquely rather than realistically shabby (though he *does* have rather unlovely features and a suggestion of a blue chin); and for all its dramatic lighting and life-size pretensions, the picture is curiously unexciting. What Gautier's reactions do demonstrate is just how slick and sentimental the run-of-the-mill Salon painting must have been if Manet's effort looked like a masterpiece of realism. It is also significant that another critic was prepared to praise Manet for depicting a 'muleteer' (that

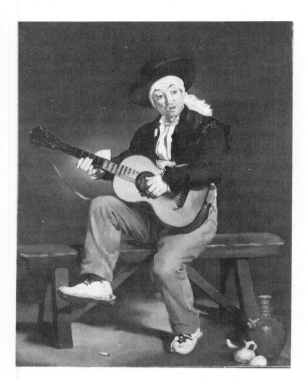

The Spanish Singer. 1860. When exhibited at the 1861 Salon, this painting was much admired, and was awarded an Honourable Mention. It was the last popular success Manet was to know for well over a decade. Metropolitan Museum of Art, New York, Gift of William Church Osborn, 1949.

Lola de Valence. 1862. Spanish exoticism fascinated Frenchmen for most of the 19th century, and Manet himself felt its spell strongly. The subject here was the principal dancer of a troupe appearing at the Hippodrome in Paris. Musée du Louvre, Paris.

is, a fellow who was visibly one of the lower orders) making music in a room with bare walls, and with an onion and a cigarette end – presumably the impedimenta of brutal realism – lying on the floor.

The Spanish Singer probably owed some of its success to the popularity in France of all things Spanish. The great Romantic movement that dominated the European arts in the early 19th century had made a cult of 'primitive' passion and the exotic; and to Frenchmen these qualities seemed embodied in colonial North Africa, on the other side of the Mediterranean, and in Spain, just across the Pyrenees but remote in customs and temperament. Spain meant the bullfight, castanets and heel-drumming dances, costumes that were either starkly black and white or brilliantly colourful, and a pride and ferocity that Frenchmen had experienced at first hand – and to their cost – during their attempt to hold down Spain from 1808 to 1813. Such features made Spain and the Spaniards splendidly glamorous, especially to the frock-coated 19th-century Parisian, easily convinced that his own way of life was banal and passionless. This contrast dominates Prosper Mérimée's *Carmen* (1843), later a famous opera, which is only one of a score of 'Spanish' works that appear in French literature. The Emperor Napoleon III gave the cult a further impetus in 1853, when he took a Spanish bride, Eugénie de Montijo, and Spanish performers (including a possible model for *The Spanish Singer*) were popular in Paris.

By tackling Spanish subjects Manet could be said to have exploited '*Espagnol-isme*', but the truth was almost certainly that he was as fascinated by Spain as

everybody else; furthermore, his painting was deeply influenced by what he knew of such Spanish masters as Velázquez and Goya, who reinforced his predilection for tonal contrasts and elimination of detail. Numerically, if not qualitatively, Spanish subjects dominated his painting of the early 1860s, ranging from the actual to the fanciful. *Spanish Ballet* (1862) portrays a real company that was appearing at the Hippodrome in Paris, and its principal dancer was the subject of Manet's opulent *Lola de Valence*. By contrast, in *Mlle. Victorine in the Costume of an Espada* (1862) Manet dressed a favourite model as a matador and posed her, flourishing sword and cape, in absurd isolation from the bullring drama going on behind her. He also executed several more convincing paintings of bullfights after he had seen the real thing in Paris (1863) and again later in Spain (1865).

As Manet established himself in the world of Parisian art and letters, he made a number of distinguished acquaintances including Théophile Gautier, the composer of light operas Jacques Offenbach, and the poet Charles Baudelaire. Manet became particularly friendly with Baudelaire, and may well have been decisively influenced by him. We have seen that *The Absinthe Drinker* seems to have been suggested by Baudelaire's work; and the poet returned the compliment by writing verses for *Lola de Valence*. As well as composing his lyrical 'flowers of evil', Baudelaire was a notable art critic who advocated modernity of subject and outlook; as early as 1845 he had asserted the need for a painter who would reveal the poetry of neckties and polished boots – on the face of it, the opposite kind of painter to Manet, who was by now apparently immersed in Spanish romance. Baudelaire returned to the attack in the essay *The*

Painter of Modern Life, in praise of Constantin Guys, a relatively minor talent with a sharp eye for Parisian foibles and follies; the essay was not published until 1863, but may well have been seen by Manet since it had been written several years earlier.

Music in the Tuileries could be taken to be Manet's answer to Baudelaire's exhortations. It is modern in spirit as well as subject, and original in conception and execution. The fashionable crowd, casually assembled to hear an open-air concert, was entirely of its time and place; it is, collectively, the 'hero' of the painting, not any one central figure or group, and the fact is emphasized by the composition, which sets the eye moving restlessly about – like the crowd itself. The composition is also noticeably flattened – that is, there is little sense of depth – since Manet preferred to strengthen the impact of his painting by bringing all its elements forward, close to the front of the imaginary picture space; he used this technique regularly, with the result that he was to be just as regularly accused of incompetence in his handling of perspective. Later, however, his example was to be followed by other great masters (Cézanne, for instance, and Matisse) who valued the unity of the picture surface more highly than literal, 'photographic' realism.

However, in Manet's picture the sense of reality is not weakened by such compositional devices. The place is a real French park, the ever-fashionable Tuileries Gardens, with its gravel paths, wrought-iron chairs and trees in full leaf; the people are gentlemen in gleaming hats, frock-coats and light trousers, and ladies whose elegance is only a little modified by the mid-Victorian fashion for bonnets and crinolines, soon to give way to more flatteringly svelte styles. Manet is said to have made sketches for the painting on the spot, and the crowd is actually a far from anonymous one: Gautier, Baudelaire, the painter's brother Eugène, Offenbach, Manet himself and a number of other men- and women-about-Paris can be identified with fair certainty. The date of the painting is disputed, but the probabilities seem to favour the summer of 1862; if this is correct, 1862–3 was an *annus mirabilis* for Manet, since it was certainly the period

Portrait of Charles Baudelaire. 1862. An etching of the great French poet and art critic. He was a close friend of Manet's, and he probably encouraged the artist to become a 'painter of modern life'. Bibliothèque Nationale, Paris.

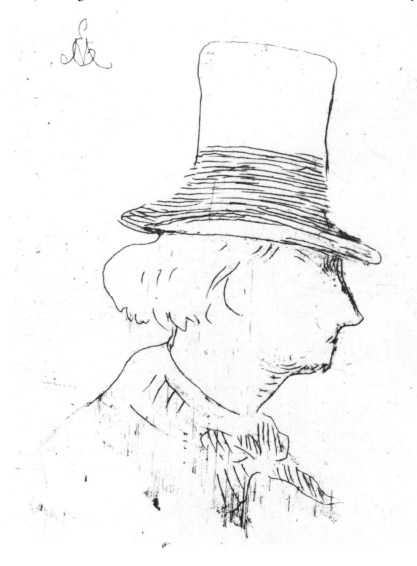

during which he also painted his great modern nudes, *Déjeuner sur l'Herbe* and *Olympia*, of which there will shortly be much more to say. From this time, modern subjects were of decisive importance in Manet's development, although another two or three years went by before his earlier mixture of Spanish, low-life and old-master-imitation works virtually disappeared.

In February and March of 1863, *Music in the Tuileries* and thirteen other paintings by Manet were displayed at 'Chez Martinet' on the Boulevard des Italiens. This was a little gallery owned by Louis Martinet, who had been Manet's dealer for the previous two years; such public exposure as he gave to Manet on this occasion was the nearest thing in France to a one-man show of the 20th-century kind, and few artists achieved even this. Hence the importance, for an artist's reputation, of the Salon, whose 1863 hanging committee Manet probably hoped to predispose in his favour by getting good newspaper reviews for the works seen at Martinet's. However, the show was not a success; even *Lola de Valence* and other 'Spanish' canvases, which now look innocuous enough, were criticized for the 'rawness' of their colour and the absence of the meticulously rendered detail and smooth finish which the public expected. However, the show did serve to bring Manet's paintings to the attention of young artists such as the future Impressionist Claude Monet and his friend Frédéric Bazille, who wrote that 'An experience like this is worth a whole month's work.'

For the Salon of 1863 Manet submitted two paintings of Spanish subjects, *Mlle. Victorine in the Costume of an Espada* and *Young Man in Majo Costume* (for which Eugène Manet posed), and the ambitious *Déjeuner sur l'Herbe* ('Luncheon on the Grass'). All these were rejected. But on this occasion Manet was far from alone: in a fit of unprecedented severity, the committee refused almost 3,000 paintings sent in for their consideration, and the disappointed artists set up an outcry against the injustice of the system. At this point the Emperor intervened and, in a populist gesture typical of his political style, decreed that the public should be allowed to decide the merits of the case: if the artists so wished, their rejected works would be put on display at a separate exhibition in the Palais d'Industrie. This show, the Salon des Refusés, opened on 15 May 1863, a fortnight later than the official Salon, and enjoyed an overwhelming success – but a *succès de scandale* rather than *d'estime*.

Music in the Tuileries. 1862. A highly original conception – the crowd as hero – and an utterly modern one in an age notorious for the bogus classicism of its serious art. National Gallery, London.

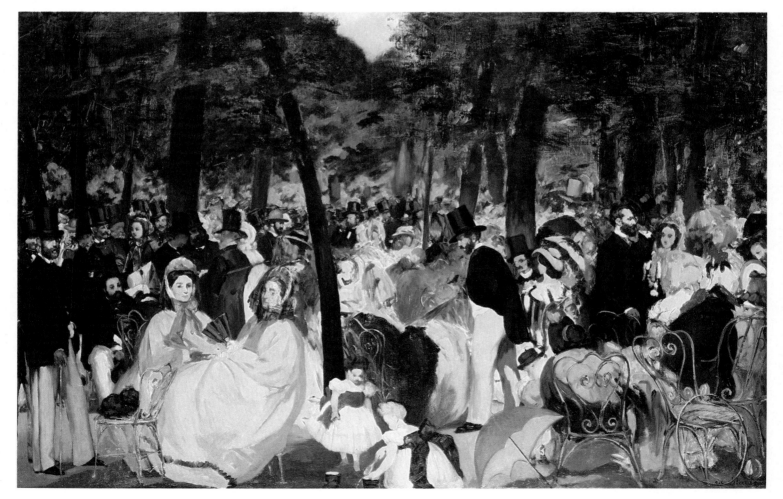

Second Empire Scandals

Primed by the newspapers, people expected to find the exhibits at the Salon des Refusés ridiculous, and started laughing almost as soon as they had passed through the turnstiles separating the show from the official Salon. Since most of the rejected paintings were thoroughly orthodox in style, the reaction was almost certainly imitative and excessive, even if there were some – surely not more than a few – visibly incompetent examples. However, the worst abuse was reserved for two of the best paintings in the show: *The White Girl*, by the young American artist James McNeill Whistler, and – most spectacularly unsuccessful of all – Manet's *Déjeuner sur l'Herbe*. This picture evoked anger and indignation rather than mere laughter; when the Emperor and Empress visited the Refusés, Napoleon III gave the public a lead by declaring that the *Déjeuner* was 'an offence against modesty', and Eugénie turned away, pretending that she had not seen it. Even sympathetic critics doubted Manet's good taste, while the hostile Chesneau commented that Manet should set himself to learn drawing and perspective, and should stop trying to become famous by causing a scandal.

Manet can hardly have expected such a response; the *Déjeuner* is a very large, ambitious picture, of the sort that a 19th-century artist painted when he felt ready to make his bid for a place at the head of his profession. We can only suppose that Manet miscalculated the combined effects of his subject and style on less sophisticated contemporaries. Although his offence was compounded by his style, with its bold contrasts and cursory passages, his contemporaries were most conscious of his 'immoral' subject matter. A naked girl sits on the grass with two young men; she has presumably been bathing in the nearby stream from which another girl emerges in her shift. (Manet's original title for the painting was *Le Bain*, 'The Dip'.) The young men are not gods or sprites, but ordinary men in their everyday clothes; and modern clothes at that – jackets, trousers and boots such as might be worn by any respectable gentleman visiting the Palais d'Industrie with his respectable wife. Brought down to earth in this non-Olympian fashion, the girl's nudity was embarrassing. She herself was not particularly come-hither (with that perky 'modern' smile and lack of languorous abandon), and the whole group was quite decorously arranged; but the heap of

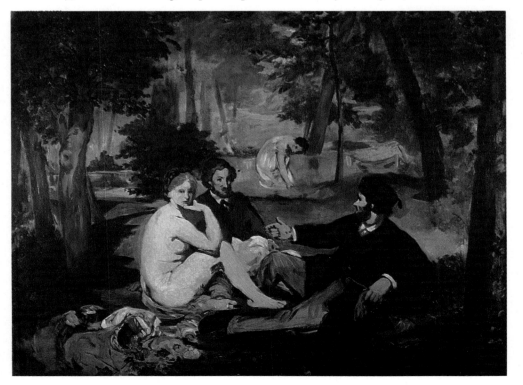

Déjeuner sur l'Herbe. 1862–3. A study for Manet's large *Déjeuner* (page 24), this is about a quarter of the size of the finished work. Courtauld Institute Galleries, London.

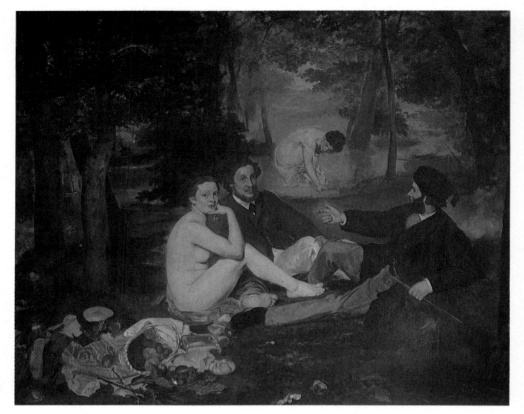

Right: *Déjeuner sur l'Herbe*. 1862–3.
Manet's scandalously modern version of a
hallowed subject (Giorgione's *Concert
Champêtre*, page 26). It made him
notorious, somewhat to his embarrassment.
Musée du Louvre, Paris.

Above: Detail from *Déjeuner sur l'Herbe*.
Manet's vivid colour and forceful, cursory
brushwork were highly unorthodox in their
day, as a comparison with Cabanel's
acclaimed *Birth of Venus* (opposite) will
make apparent. Musée du Louvre, Paris.

discarded clothes in the foreground of the painting makes the spectator aware
that he is not looking at 'the nude', but at a girl who has undressed. Just how
unacceptable this was can be understood by comparing the *Déjeuner* with the
great success of the official Salon. Alexandre Cabanel's *Birth of Venus* was
purchased by the Emperor himself, and earned its creator the coveted Légion
d'Honneur. Its subject is the mythical sea-birth of the goddess of love, who is
shown in Cabanel's work as a smoothly curvaceous young lady, delivered to the
spectator by the waves in an erotically swooning condition hardly suggestive of
a newly created being: she is sexy, but carefully removed from the mundane
(let alone modern) world in which people dress or undress. The painting was
regarded as quite daring, but so tastefully done that it avoided offence.

Cabanel's slick 'chocolate box' mythology had no genuine relationship with
the classical tradition; it was Manet's 'modern' *Déjeuner* that drew on the past
and reinterpreted it with creative energy. The idea of the nude in a pleasurable
setting with men in contemporary dress was certainly suggested by the 16th-
century Venetian painter Giorgione's *Concert Champêtre*, which Manet must
have known well since it was in the Louvre; and the arrangement of the main
figures was taken directly from the group of gods with a nymph in a painting
by another Renaissance master, Raphael, with which Manet was familiar
through an engraving by Marcantonio Raimondi.

Such delicate allusions, common in Manet's work, were not always noticed.
Even when they were, the critics did not consider them an excuse for Manet's
immorality: what was glorious in Giorgione somehow became reprehensible in
the 19th-century artist. The confusions of attitude that resulted can be seen
with particular clearness in an English art critic's reaction to the *Déjeuner*,
printed in the *Fine Arts Quarterly Review*:

> I ought not to omit a remarkable picture of the realist school, a translation of
> the thought of Giorgione into modern French. Giorgione had conceived the
> happy idea of a *fête champêtre* in which although the gentlemen were dressed,
> the ladies were not, but the doubtful morality of the picture is pardoned for
> the sake of its fine colour . . . Now some wretched Frenchman has translated
> this into modern French realism, on a much larger scale, and with the horrible
> modern French costume instead of the graceful Venetian one . . . There are
> other pictures of the same class, which lead to the inference that the nude,
> when painted by vulgar men, is inevitably indecent.

Giorgione's idea was, it seems, a happy one – yet of doubtful morality; it was
pardoned for the sake of its fine colour, and, anyway, its figures were in the
graceful Venetian costume – not like the horrible modern French costume;
besides which, the wretched Frenchman's picture was on a much larger scale,

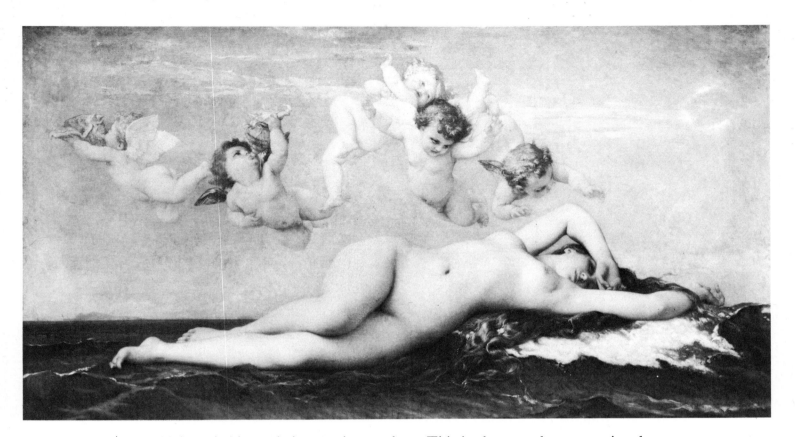

Alexandre Cabanel. *The Birth of Venus.* 1863. This painting was a huge success at the 1863 Salon, and was purchased by the Emperor Napoleon III – the authority who was shortly afterwards to condemn Manet's *Déjeuner* (opposite) as 'an offence against modesty'. A comparison between the *Venus* and the *Déjeuner* (and later the *Olympia*, page 31) confirms that it was Manet's modern subjects and bold painting style, not any erotic element in his work as such, that shocked contemporaries. Musée du Louvre, Paris.

which probably made it more immoral . . . This is about as close to a printed series of indignant, unreasoning splutters as it is possible to get. The writer, one P. G. Hamerton, gives himself away completely when he describes 'two Frenchmen . . . sitting on the very green grass with a stupid look of bliss', for their Frenchness is a mere assumption (probably based on the Anglo-Saxon notion that 'Latin lovers' were enviably, successfully, immoral), and happens to be wrong, since one of the male models was Manet's brother-in-law, the Dutch sculptor Ferdinand Leenhoff. And the 'look of bliss' is not visible on the canvas but evidently existed in Hamerton's overheated imagination. His remarks are, of course, particularly naive and ill-rationalized, but just for that reason they give us an insight into the emotional springs of much destructive 19th-century criticism.

Such criticism might wound Manet's feelings, but its effect on the sales of his pictures was relatively unimportant; on the death of his father in 1862, he inherited enough money to ensure that he remained independent for life, although he was, on occasion, absurdly extravagant. The death liberated Manet in other respects, too. He had played the dutiful son as required, dining with his parents almost every evening and concealing from his father the existence of a liaison that might have caused him to be disinherited. (Cézanne, who had the advantage of being an only son – and therefore, in partriarchal terms, the inevitable heir – was nevertheless made to suffer when his father discovered that he had acquired a mistress and a son.) The liaison was with Suzanne Leenhoff, a Dutch girl who had been Manet's piano teacher in about 1850 when, it is generally inferred, she and Manet became lovers. It is only inference – although from evidence that makes it a near-certainty – because Manet's discretion was so complete that his twelve- or thirteen-year relationship with Suzanne remained unknown to the world, and in October 1863 even close friends such as Baudelaire were astonished to hear that their apparently unattached painter-friend had married Suzanne – discreetly as ever, in Holland, so that speculation would be reduced to a minimum.

An equally well-concealed secret was that Suzanne had given birth to a son, named Léon, on 29 January 1852; the father of the boy was said to be a certain Koëlla, who probably never existed. Manet became the boy's godfather, and Léon was passed off as Suzanne's younger brother. The likelihood that Manet was Léon's father becomes a virtual certainty in view of the will made by the painter a few months before his death: he left everything to his wife, stipulating that she should in turn leave it to 'Léon Koëlla (known as Leenhoff), who has cared for me with such devotion'; the 'godson' was also to receive 50,000 francs from the posthumous sale of Manet's works. Significantly, Manet stated that 'I

think that my brothers will agree entirely with this bequest' which they would hardly have done if the effect of the will had been to disinherit them for a man who was not a blood relation of Manet's. Léon appears in many of Manet's works as a singularly handsome boy and young man: he is the *Boy with a Sword* (1861), the *Boy Blowing Soap Bubbles* (1867), and the charming young man in the superb *Luncheon in the Studio* (1868); he is seen reading aloud to his mother in *Reading* (1868), and with her again in *Interior at Arachon* (1871); he is the *Young Man with a Pear* (1869); and turns up yet again, on a bridge, in *Oloron-Sainte-Marie* (1871) and *Croquet at Boulogne-sur-Mer* (1871).

Manet portrayed his wife about the same number of times, but over a longer span of time. She was a plump, rather dumpy woman and, except in *Reading*, Manet seems to have made no serious attempt to flatter her; she appears to best effect in *Madame Manet at the Piano* (1873) and *Madame Manet in the Conservatory* (1879). However, the unforgettable image of her is the least flattering, a pastel, in sensuous, glowing colours, of *Madame Manet on a Divan* (1874/78) with her feet up and a (no doubt accidental) air of having come in, tired and cross, from a hard day's shopping.

Even by the standards of the time, Manet's concern to avoid gossip about his family affairs seems almost neurotic; other men had been known to marry their long-time mistresses (Pissarro, Monet and Cézanne all did so), and they commonly acknowledged children born out of wedlock. Manet, perhaps because he was born into a somewhat higher class than most of his colleagues, showed a civil servant's preoccupation with respectability – or was it a clubman's strictness over 'good form'? At any rate, the apparently forthcoming Manet, noted as a conversationalist and wit, habitually concealed his private affairs and revealed very little of his inner life or artistic intentions. His surviving letters are conventional in tone and content, leaving both his life and his career unilluminated. Even on quite straightforward matters – such as the exact motive for his artistic borrowings and allusions – we have no certain statement made by Manet himself; and his recorded thoughts and opinions are few, except in the pat, hindsightful pages of the aged Antonin Proust. That is why any study of Manet, a century after his death, remains full of speculative passages. Most of his contemporaries disliked and misunderstood his work; later generations have learned to admire it but cannot claim to understand it fully even yet. At some point in almost every discussion of an important painting by Manet, maddening uncertainties arise and radically different explanations suggest themselves.

Why, for example, did he submit a *Dead Christ with Angels* and a *Bullfight* to the Salon of 1864? One interpretation is that he was playing safe, hoping that the combination of a religious and a romantic picture would automatically find general favour, so that the fuss over *Déjeuner sur l'Herbe* would be the more easily forgotten. The uproar over the Refusés had led to a number of administrative reforms, including the holding of the Salon every year instead of biennally; the effect of this was to soften the blow of a rejection (which had previously meant that an artist's work would remain out of the public eye over a four-year period), but the shorter interval between showings perhaps made it harder to live down a scandal. Manet's entries were accepted (the new hanging committee

Marcantonio Raimondi's *Judgement of Paris*, an engraving after a painting by Raphael. Manet was in many respects a traditionalist, reinterpreting established subjects and compositional devices. This group of river gods and nymphs was clearly the original for the group in *Déjeuner sur l'Herbe* (page 24). Metropolitan Museum of Art, Rogers Fund, 1919.

Giorgione. *Concert Champêtre*. This Venetian Renaissance masterpiece undoubtedly inspired Manet to produce a 19th-century version of the subject in his *Déjeuner sur l'Herbe* (page 24). Musée du Louvre, Paris.

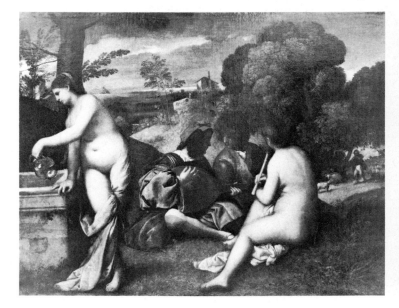

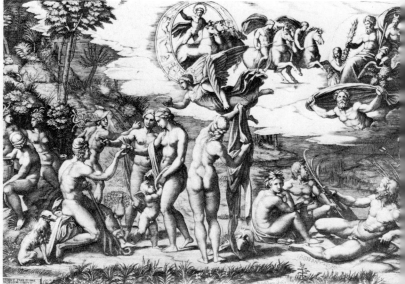

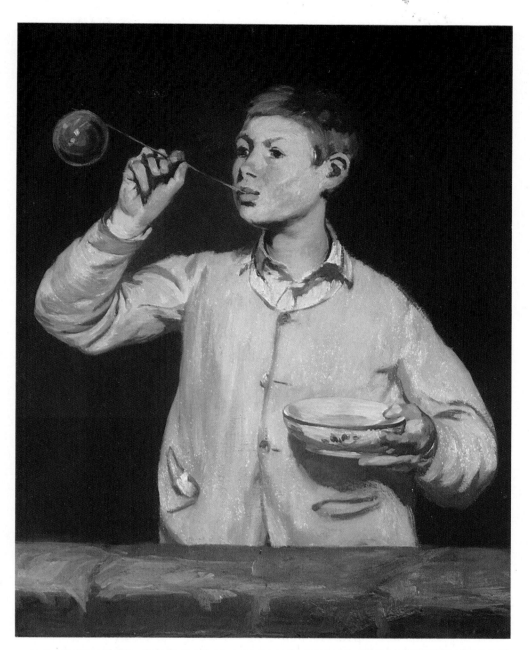

Boy Blowing Soap Bubbles. 1867. The subject is Léon Koëlla, Manet's little 'brother-in-law' — in fact almost certainly his son. Museu Gulbenkian, Lisbon.

Lunch in the Studio. 1868. Manet at his most soberly poetic. The elegant young man is Léon Koëlla. Bayerische Staatsgemälde-sammlungen, Munich.

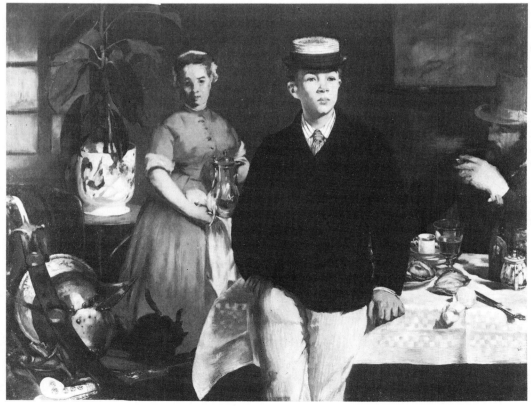

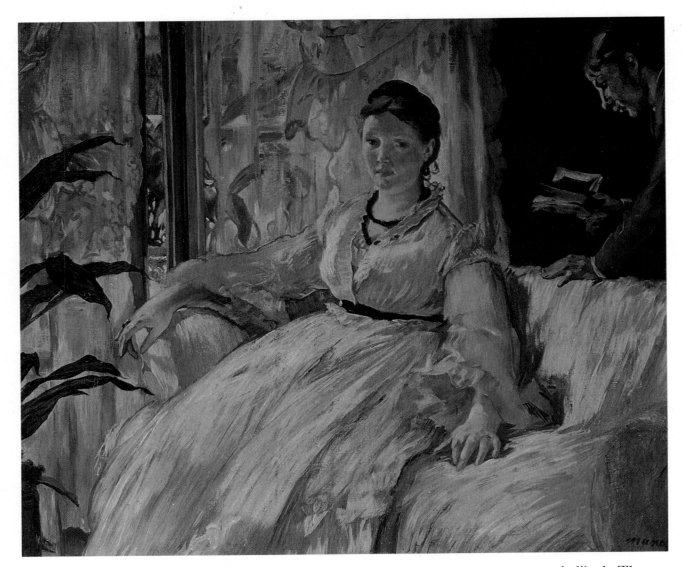

Reading. 1868.
Madame Manet is
shown listening to a
reading by her son,
Léon Koëlla. Musée
du Louvre, Paris.

was more liberal – or more cautious), but they were not much liked. The *Bullfight* was so harshly criticized for its unrealistic perspective that Manet cut up the canvas, preserving only two large fragments, of which the best known, displaying the painter's characteristically contrasted velvety black and textured white, is *The Dead Bullfighter*. The *Dead Christ with Angels* was attacked on the grounds that the central figure was corpse-like – a most odd objection in view of the subject, but one quite in keeping with the 'Germanicus' Big Toe' theory of stylistic appropriateness: even a dead man-god was not supposed to look like . . . a dead man. Whether or not Manet was making a serious attempt to reinterpret traditional religious painting (as has certainly been argued), it can hardly be said that the subject was suited to his particular genius or temperament, and it seems an indication of a persistent uncertainty that he should have thought otherwise.

Manet's submissions for the 1865 Salon were, on the face of it, even more oddly paired than his efforts of the previous year. *Jesus Mocked by the Soldiers* and a nude, *Olympia*, were accepted for exhibition, but their public reception was calamitous. The religious work was again denounced for its sordid realism, but the hostility it attracted was slight by comparison with the storm over *Olympia*, which has been called the scandal of the century. Manet must have feared something of the sort, for he completed the painting some time in 1863 but held it back until the 1865 Salon, presumably in the hope that the atmosphere of the art world would become more liberal. In the event, *Olympia* was savagely abused. One critic called her 'a female gorilla', and warned that pregnant women and young girls would look on her at their peril; another referred to her as an 'odalisque with a yellow belly, a low model picked up I don't know where'. The old Romantic, Théophile Gautier, who had enthused over *The Spanish Singer*, found Olympia's flesh a 'dirty' colour, and complained that the modelling of the figure was non-existent, so that she appeared to have neither bones nor muscles. Most ordinary spectators simply giggled, but it is said that the possibility of malicious damage to the picture was strong enough

Madame Manet at the Piano. 1868. This work had its origin in a tiff between Degas and the Manets. Degas executed a painting of Manet listening to his wife playing the piano, but the couple were dissatisfied with the result, and Manet removed the figure of his wife from the canvas — an astonishing act of philistinism, especially when directed against the work of a colleague and friend. Degas got to hear of it and, naturally furious, took his picture back. This is Manet's subsequent portrait of his wife in the same attitude, showing how (he felt) Degas ought to have done it. Musée du Louvre, Paris.

Angelina. 1865. Musée du Louvre, Paris.

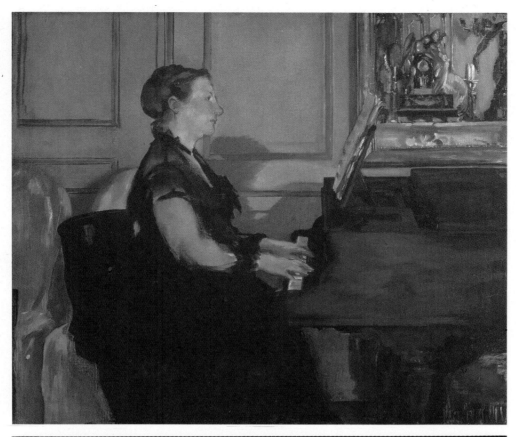

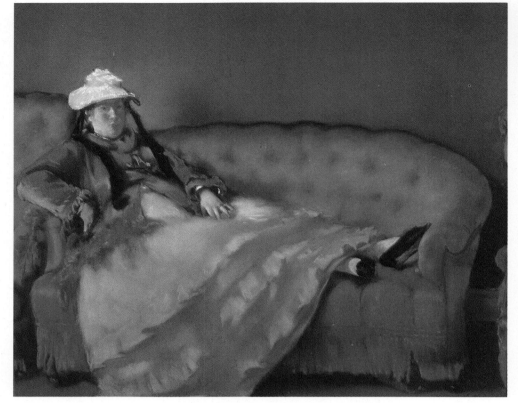

Far right, top: *Olympia*. 1862–3. The exhibition of this picture at the 1865 Salon has been called the artistic scandal of the century. Its boldness of subject and treatment can be better appreciated if it is compared with a conventionally successful painting such as Cabanel's *Birth of Venus* (page 25). Musée du Louvre, Paris.

Right: *Madame Manet on a Divan*. 1874/78. A splendid example of the distinctive texture and brilliant colour Manet achieved using pastels, a medium he turned to with increasing frequency in his later years. Musée du Louvre, Paris.

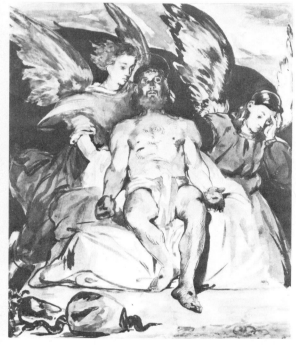

Above: *Dead Christ with Angels*. 1864. Musée du Louvre, Paris.

for it to be moved up into the 'sky' – that is, high up on the wall, where it was hard to get at and also hard to see. (Thousands of paintings were shown at the Salon, and its walls were crammed with canvases both horizontally and vertically, almost from floor to ceiling; if an artist had influential friends, they would try to ensure that his work was hung in a prominent place.)

Manet was visibly upset by the furore. When the waiter brought him the newspapers at a café (as was then customary) he snapped, 'Who asked you for them?' He wrote to Baudelaire, who was then living in Brussels, complaining that he was sick of being insulted and laughed at; the poet tried to put heart into him by shrugging off the insults and laughter as the reward of genius: did Manet think he deserved better than the great French writer Chateaubriand or the German composer Wagner, both of whom had also been laughed at and hadn't died of it? Baudelaire also remarked shrewdly on Manet's 'lack of assurance', showing that, unlike most of the painter's friends, he did not identify Manet's boulevard persona with his character and feelings as an artist. Manet seems to have remained unconsoled. When the Salon closed, he left the Parisian art world behind him, recuperating for a couple of weeks by the sea at Boulogne and then making his first, belated trip to Spain, the source of so much of his early inspiration.

The accusations against *Olympia*, although expressed with greater ferocity, were much the same as those levelled at Manet's earlier work. His 'flat' style offended: Gautier correctly noted the relative lack of modelling, and was echoed by Courbet ('it's the Queen of Spades stepping out of her bath'); but it seems to have occurred to neither that, since Manet's style was evidently a matter of deliberate choice, it might be worth more careful scrutiny. *Olympia*'s stylistic peculiarities no doubt helped to draw attention to the impropriety of the painting. Aesthetics and morals fused in spectators' reactions to the girl herself: she was ugly and 'dirty'-skinned because she was real, not smooth and impossibly rosy, but with a suggestion of body hair and, here and there, shadowed or puckered flesh; and, being real, she was (as we have seen) necessarily immoral. The girl's 'ugliness' was purely a matter of artistic and moral convention, of course; outside this context, most of the spectators would have admired her beauty, which was very much in the contemporary fashion for small and slender figures. The 'female gorilla' made people feel uncomfortable because, as Emile Zola told his readers, she had 'the serious fault of closely resembling young ladies of your acquaintance'.

But what made *Olympia* so vastly more scandalous than *Déjeuner sur l'Herbe*? The answer seems to be that *Olympia* included a number of elements that gave a strong additional emphasis to the contemporary and sexual aspects of the

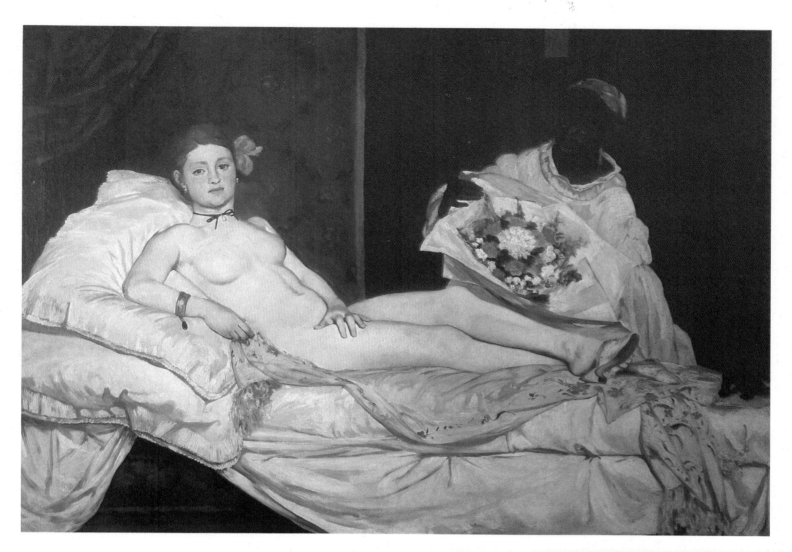

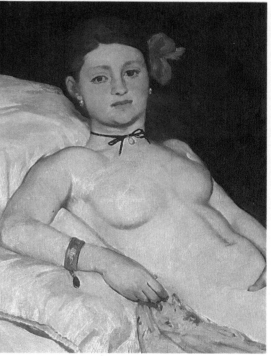

painting; Manet can hardly have put them in without knowing what he was doing, yet their presence makes it hard to explain his bewilderment in the face of the subsequent attacks on him. First there are the girl's erotic, modern trappings (the neck-ribbon, the bracelet, the *one* satin slipper she wears), which all serve to focus the attention on her nakedness; the black servant and the cat can also be regarded as erotic 'props'. Olympia gazes straight out of the picture at the spectator who, if he was a 19th-century gentleman, might well have felt himself in the position of an amorous caller who had just entered the room: the servant is displaying his bouquet – or perhaps his rival's – while Olympia looks at him with self-possessed indifference and the cat bristles, arching its back and putting up its tail in a long question-mark.

Furthermore, there could be no reasonable doubt concerning the girl's professional status. Quite apart from the fact that respectable women were not supposed to deck themselves out and display themselves in such a fashion – even for their spouses – the title of the painting was a give-away; not a single reviewer mentioned the fact, but in French novels and plays, 'Olympia' had virtually

Above left: Study for *Olympia*. Bibliothèque Nationale, Paris.

Above: Detail of *Olympia*. 1862–3. Musée du Louvre, Paris.

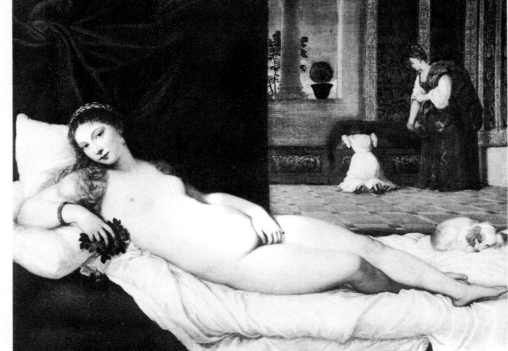

Right: Titian. *The Venus of Urbino.* This masterpiece of 16th-century Venetian painting was a prime source for Manet's *Olympia.* The conscious modernity and cool sexuality of the *Olympia* gain added piquancy from a comparison with the glowing sensuality of the *Venus.* The contrast extends to details such as Manet's substitution of a venomously alert cat for Titian's sleepy lapdog. Galleria degli Uffizi, Florence.

Below: *Portrait of Victorine Meurend.* 1862. This attractive red-haired girl was for years Manet's favourite model — for, among others, the notorious *Déjeuner* (page 24) and *Olympia* (page 31). Museum of Fine Arts, Boston, Gift of Richard C. Paine, in memory of his father, Robert Treat Paine II.

The Venus of Urbino. c. 1856. Manet's copy after Titian's great painting. He executed it during a youthful visit to Florence. Rouart Collection, Paris.

become a stock name for the heartless, mercenary hussy. The prostitute played a considerable role in French life, and courtesans – that is, high-society prostitutes such as the Imperial 'Guard' and the later splendidly named *grandes horizontales* – ruined millionaires and created fashions. Here, Manet seemed to be saying, was one of the supreme realities of modern society; and to drive home the point by means of a striking contrast, he based his own work on Titian's enchanting *Venus of Urbino*, then believed to represent a Renaissance courtesan, which he had copied years before in Florence. Manet's witty ringing of the changes on Titian's painting (for example, substituting a cat on the *qui vive* for a sleeping lapdog) were all in the direction of greater coolness; Olympia is neither warmly inviting, like Titian's Venus, nor coyly yielding in the preferred 19th-century fashion. She is not even a scornful mistress or a *femme fatale*, but simply neutral in attitude; it might almost be said that the girl is the least glamorous item in the scene. All this must have made *Olympia* puzzling indeed – a serious painting of a light lady, and an immoral work that made no attempt to arouse desire. Astonishingly, in their indignation and confusion the critics entirely overlooked *Olympia*'s relationship with the *Venus of Urbino* (it was not actually noted in print until 1890!). In retrospect, it seems inevitable that Manet's masterpiece should have been misunderstood and reviled.

Before leaving *Olympia* it is worth mentioning that the girl in it was the same red-haired beauty who had sat for the *Déjeuner*. Her name was Victorine Louise Meurend (or Meurent or Meuran), and she first sat for Manet in 1862, when she posed for *The Street Singer* and *Mlle. Victorine in the Costume of an Espada*, and was the subject of a small head-and-shoulders portrait. She remained his favourite model for several years, appearing in *Woman with a Parrot* (1866), *Woman Playing a Guitar* (1866) and, as late as 1873, in *The Railway*. She later took up painting – to some effect, it is said – and one last glimpse of her is in the pages of George Moore's *Memoirs of My Dead Life* (1906) as a thin, chain-smoking woman who, Moore noted, didn't wear stays.

Manet's public reputation never really recovered from the *Olympia* scandal. But it made him a hero to the avant-garde élite of younger men whom ill-wishers began to call *la bande à Manet* – 'Manet's gang'.

Manet
and His Gang

Manet was now in his thirties. A number of descriptions of his appearance and social manner exist, and since they are substantially in agreement with one another, it is possible to synthesize them into a single composite pen-portrait. It necessarily reads like a eulogy, but there is no reason to suppose that the various witnesses were distorting the truth.

Manet was of medium height, square-shouldered, slender-waisted and fair-haired, with a carefully tended blond beard; according to the Irish writer George Moore, his face was both handsome and intellectual in expression. Whether in the city or the country, he wore a tall hat with a flat brim, a waisted frock-coat or jacket, light trousers and elegant boots; he sported a cane and walked with a hint of a swagger. He was a perfect gentleman – courteous, albeit with the casual Parisian air, as well as charming and frank. His conversation was pointed and witty, and although he could be sharp or even lose his temper on occasion, he normally conducted his conversational battles with irony or gentle mockery rather than abuse. He was evidently attractive to women, but too discreet to reveal the consequences, if any.

This description tells us all we need to know about Manet the *flâneur* and social man; significantly, there is less information – and less consensus – about his personal and artistic life. As has already been suggested, his was probably the sort of charm and apparent frankness that a man assumes in order to conceal rather than display his inner self. There may have been deep psychological reasons for Manet's behaviour, but it seems just as likely that he was adhering to notions of good form that were, after all, quite widely adopted in the 19th century. At any rate, it was only very occasionally, under the pressure of hostility and disappointment, that Manet lowered his man-of-the-world mask.

Then as now, the café was a great centre of French social life, and Manet regularly met his friends at some chosen rendezvous – first the Café Tortoni, then the Café de Bade (both on the Boulevard des Italiens) and, from some time in the later 1860s, at the Café Guerbois, not far from his home on the Boulevard

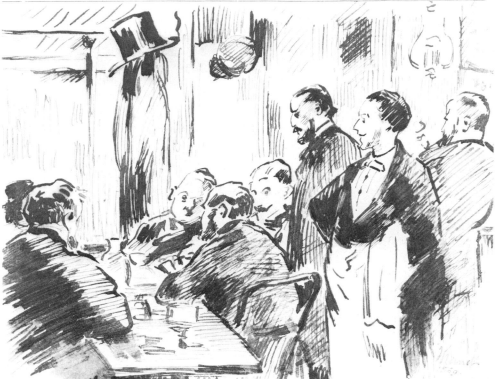

Parisian Café. 1869. This is perhaps the Café Guerbois, where Manet and his cronies gathered in the late 1860s. It is, at any rate, a lively pen-and-ink evocation of the Parisian café as a social and intellectual centre. Fogg Art Museum, Harvard University, Cambridge, Massachusetts, Bequest of Meta and Paul J. Sachs.

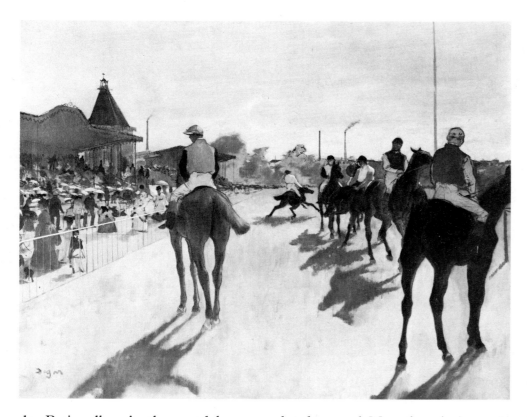

Left: Edgar Degas. *At the Races, in Front of the Stands*. 1869–72. Seemingly casual and spontaneous, this work has a 'snapshot' effect which is enhanced by the way in which the right-hand edge of the picture decapitates a horse. In reality, Degas's method was neither arbitrary nor spontaneous, but a supreme example of the art that conceals art. Musée du Louvre, Paris.

des Batignolles. As the scandals accumulated around Manet's paintings, the tables reserved for him at the Guerbois became a meeting place for the most talented men among those Parisian artists and writers who were in rebellion against the trite orthodoxies of official art. This convivial group, enjoying their Thursday night exchange of ideas and witticisms, in no sense constituted a school or party, but hostile critics inevitably began to write of them as 'Manet's gang'.

His oldest friend among the Guerbois regulars was probably Edgar Degas, whom he had met in the early 1860s. The two men were about the same age (Degas was two years younger) and from a not dissimilar background (Degas's father was a banker), and both were keenly interested in the pictorial possibilities of the life around them. They seem to have been closest in the years before 1865, however; significantly, their relations were rather cooler as Manet became notorious ('You're more famous than Garibaldi!' jeered Degas), and his predominance at the Guerbois evidently irritated Degas.

But then Degas was a born oppositionist, always ready to play the non-conformist, whether as an independent among academics or as an aristocrat among the plebs. Since the Guerbois circle was on the whole liberal in outlook, and some of its members were not well-born, Degas would announce that the working classes should not be allowed to come into contact with art; and since there were landscapists present, he observed that people who painted out of doors should be brought to the attention of the gendarmes. In Manet's case, however, it was conformism that provoked Degas: when Manet enthusiastically congratulated a friend on being decorated, Degas snapped, 'I'd already realized what a *bourgeois* you are, Manet!' And on another occasion he made the cutting, exaggerated but by no means baseless observation that 'Manet is in despair because he cannot paint atrocious pictures . . . and be fêted and decorated; he is an artist not by inclination but by force. He is a galley slave chained to the oar' – which was, in its way, a magnificent tribute to Manet's artistic daemon.

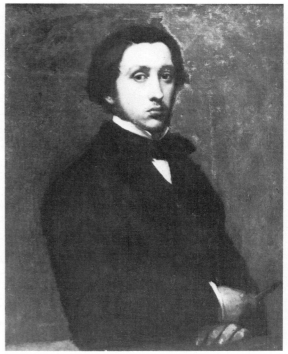

Above: Edgar Degas. *Self-portrait. c.* 1854–5. Degas, dedicated and acidulous, was at once a member of Manet's circle and his chief rival as a painter of the distinctively modern. Musée du Louvre, Paris.

Such a concentration of anecdotes makes Degas sound intolerable; but since he was in fact tolerated, he must have been less out of harmony with his fellows than the anecdotes suggest. The Guerbois was probably the scene of some vigorous conversational cut and thrust, and Manet was evidently capable of giving as good as he got. He particularly enjoyed reminding Degas that the latter's enthusiasm for modernity had been slow in developing; he would say, 'I was painting modern life while you were still painting Semiramis building Babylon!' – referring to an ambitious historical painting of 1861 that Degas would doubtless have preferred to forget.

All the same, it could be argued that Degas soon became even more whole-heartedly a 'painter of modern life' than Manet himself. Jockeys and racehorses,

laundresses, women at the milliner's, the café-concert, the ballet, the circus, even the brothel, the stock exchange and the cotton market: these, along with many superb portraits and nude studies, were the products of Degas's long lifetime (1834–1917) of unremitting artistic labour, during which he produced not only paintings but an abundance of pastels, prints and sculptures. His compositional effects, influenced by Japanese wood-block prints and the new art of photography, were of startling originality, giving his works an apparently casual, off-centre look, reinforced by the frequent presence of figures cut off by the edges of the picture, as in a photographic snap-shot. Degas is the great master of the human figure in movement, whereas Manet's preference was generally for moments of stillness. But Manet was not above borrowing from his unfriendly friend on occasion, as when he made a number of horse-racing studies at Longchamp in 1864–65; and although most of his subjects are centrally placed, he sometimes used Degas's 'cut-off' technique to effect, notably in *Nana* (1877).

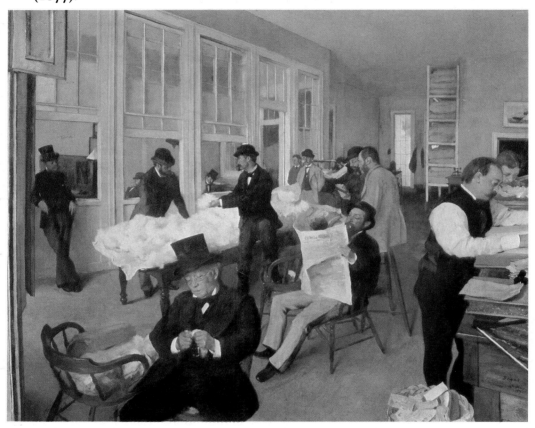

Above: Edgar Degas. *The Cotton Market, New Orleans*. 1873. Musée des Beaux-Arts, Pau.

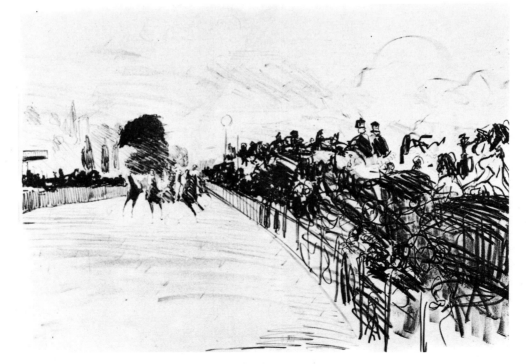

Left: Pen and ink study for the painting *Racing at Longchamps*. Metropolitan Museum of Art, New York, Rogers Fund, 1920.

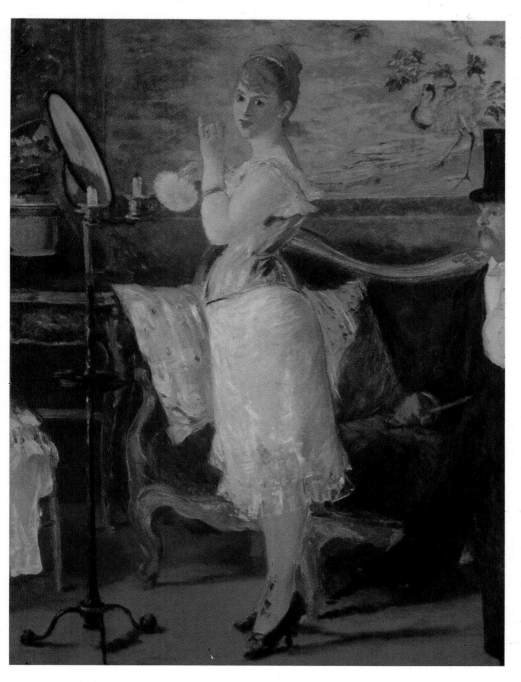

Nana. 1877. A more light-hearted version of the 'kept woman' subject (cf. *Olympia*, page 31), here inspired by a character from Emile Zola's novels. The way in which the girl's protector is cut in two exploits a device introduced by Degas, although the composition is too centrally focused to achieve Degas's characteristic 'snapshot' effect. Kunsthalle, Hamburg.

Many of the other habitués of the Guerbois were painters of a younger generation, born around 1840, for whom Manet's very existence was a heartening fact; when they were discouraged, someone would say, 'Let's go and see Manet: he'll stick up for us!' Four of them must have formed a gang-within-the-gang, since they knew one another from the studio of the academic painter Marc-Gabriel Gleyre, where they had studied until its closure in January 1864. Claude Monet, Auguste Renoir, Alfred Sisley and Frédéric Bazille were immensely talented and, like Manet himself, had not given up hope of taking the art establishment by storm.

Monet, the son of a wholesale merchant, had been brought up on the coast at Le Havre, and his main bent was for landscape; two of his paintings had been shown at the Salon of 1865, where – thanks to the similarity between their names – Manet was disconcerted to find himself congratulated on his seascapes by people who regarded his *Olympia* as detestable. Manet nevertheless thought very highly of Monet; when people visited his studio he would not talk of his own work (that would perhaps have been bad form) but often extolled his younger friend's abilities. For his part, in 1865–66 Monet was influenced by Manet's example to attempt large-scale figure paintings for the only time in his life. A huge *Déjeuner sur l'Herbe*, of which only two large fragments survive, was clearly intended to rival Manet's *Déjeuner* and to outdo it in modernity and open-air feeling; and Monet's dedication to painting outdoors was such that he had a trench dug to hold the canvas of *Women in the Garden* so that he could reach every part of it with his brush and thus avoid working on it in a studio.

Right: Frédéric Bazille. *The Artist's Studio.* 1870. Manet among the Impressionists. A plausible identification of the figures in this painting is as follows: Manet, stick in hand, discusses the picture on the easel with Monet and 'tall Bazille'; Zola, on the stairs, talks to Renoir; an amateur musician, Edmond Maître, plays the piano. Musée du Louvre, Paris.

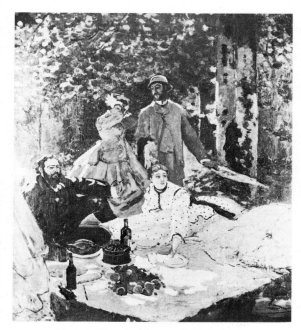

Above: Claude Monet. *Déjeuner sur l'Herbe.* Monet's version of the 'luncheon on the grass' subject, which must have been executed in conscious rivalry with Manet's *Déjeuner* (page 24). The illustration shows one of the three fragments which survive from Monet's large painting. Eknayan Collection, Paris.

Towards the end of the 1860s he turned back decisively to nature, pioneering a new style full of light, colour and movement, the style that gave rise to the Impressionist landscape.

Monet's co-pioneer was Auguste Renoir, although Renoir's most enduring impulse was towards figure painting. Of working-class origin, with experience of earning a living by painting on porcelain, café walls and sun-blinds, Renoir was a rather timid man, especially at this period of his life and in sophisticated company; in paintings and photographs he exhibits the self-effacement of a seminarist or else looks about him with the expression of a startled deer – hardly what we should expect in a man who was to become so famous as a painter of opulent nudes. Renoir was an artist of dazzling natural gifts, impatient of theories and discussions; and if the fact ultimately limited his achievement, he remains an outstanding example of a peculiarly French tradition – of painting which celebrates the joyful simplicities of life.

Both Sisley and Bazille were sons of wealthy families, and produced relatively little work during the 1860s. 'Tall Bazille', a kindly beanpole of a man, was perhaps the more promising, but his promise was cut short by his early death. Sisley was unassuming both as a man and as a painter. After 1870, the financial ruin of his family turned him into a professional artist, hardly ever free from the most bitter poverty; he painted many fine landscapes and a few superb ones, but then as now his achievement was undervalued through inevitable comparison with the scintillations of Monet and Renoir.

Another landscapist seen at the Café Guerbois from time to time was Camille Pissarro. A late starter, born in the West Indies, Pissarro was actually two years older than Manet, but he was closer to the younger men in stylistic development and eventually became a leading exponent of the Impressionist landscape. Despite his left-wing views, Pissarro was such a benevolent personality that he seemed to get on with everybody (even Degas liked him), and he had a knack for discovering and discreetly helping young painters of promise. One of these was the moody Paul Cézanne, who at the Guerbois would punctuate long, obstinate silences with outbursts of irritation, culminating in stormy exits. Concealing his timidity and inner tensions behind a coarse, blustering front, this banker's son from Aix dressed shabbily and affected a thick Provençal accent; once, having shaken hands all round at the café, he declined to shake Manet's, on the grounds that he, Cézanne, had not washed for eight days. This and other incidents go to show that Cézanne found Manet's dandyism provoking; but there may also have been a deeper reason for his hostility. In the 1860s Cézanne was a neurotic Romantic – a painter of extraordinary violence and eroticism, expressed in a heavy, agitated style. Then, against all the odds, in the early 1870s he became an Impressionist landscapist under Pissarro's influence; and from there he developed into an artist of immense constructive power and originality,

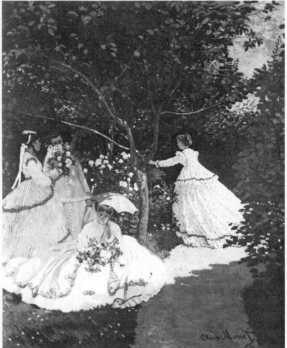

Left: Auguste Renoir. *The Swing*. 1876. One of the masterpieces of the high Impressionist period, redolent of sunlit pleasures. Musée du Louvre, Paris.

Above: Claude Monet. *Women in the Garden*. 1866–7. A very large picture; Monet, committed to outdoor painting in a way that Manet never was, had a trench dug for the canvas so that he could reach the top of it without being forced to work in a studio. Soon afterwards he abandoned figure painting on such an ambitious scale, and exploited his natural genius as a landscapist. Musée du Louvre, Paris.

creating a new pictorial language that has often caused him to be described as the father of modern art.

Even in the 1860s Cézanne may have sensed in Manet a rival or precursor. Manet was the first of the great 19th-century French painters to interest himself in that neglected genre, the still life, which Cézanne was to make into a central preoccupation. And, as Cézanne was to do, Manet violated perspective and other 'rules' for the sake of pictorial effect; for all his commitment to 'modern life', he was in no sense an artist who simply recorded what he saw. Implicit in his practice – as in Cézanne's – was the essentially modern conviction that a painting is, first of all, a two-dimensional arrangement of colours and shapes, not a copy of reality; the laws and logic of a work of art are not the same as those governing the world beyond the picture frame. *Olympia* may have appealed to Cézanne from this point of view as well as touching his exposed erotic nerve; at any rate he called the picture 'the beginning of our Renaissance', and showed his obsession with it in the early 1870s, when he painted several widely different, prankish equivalents to Manet's original, giving each of them the title *A Modern Olympia*.

Whatever his impact on Cézanne, it is unlikely that Cézanne ever impressed Manet very deeply; Cézanne's best work was not to be seen in Paris until after Manet's death. By contrast, Henri Fantin-Latour was the most gifted of several conventional painters with whom Manet was friendly. He painted a good portrait of Manet at his most dandified (1867), and provided a useful record of the 'gang' in *A Studio in the Batignolles Quarter* (1870), also known as *Homage to Manet*. (Fantin-Latour became something of a specialist in this kind of celebratory collective portraiture.) A group of friends gathers round Manet,

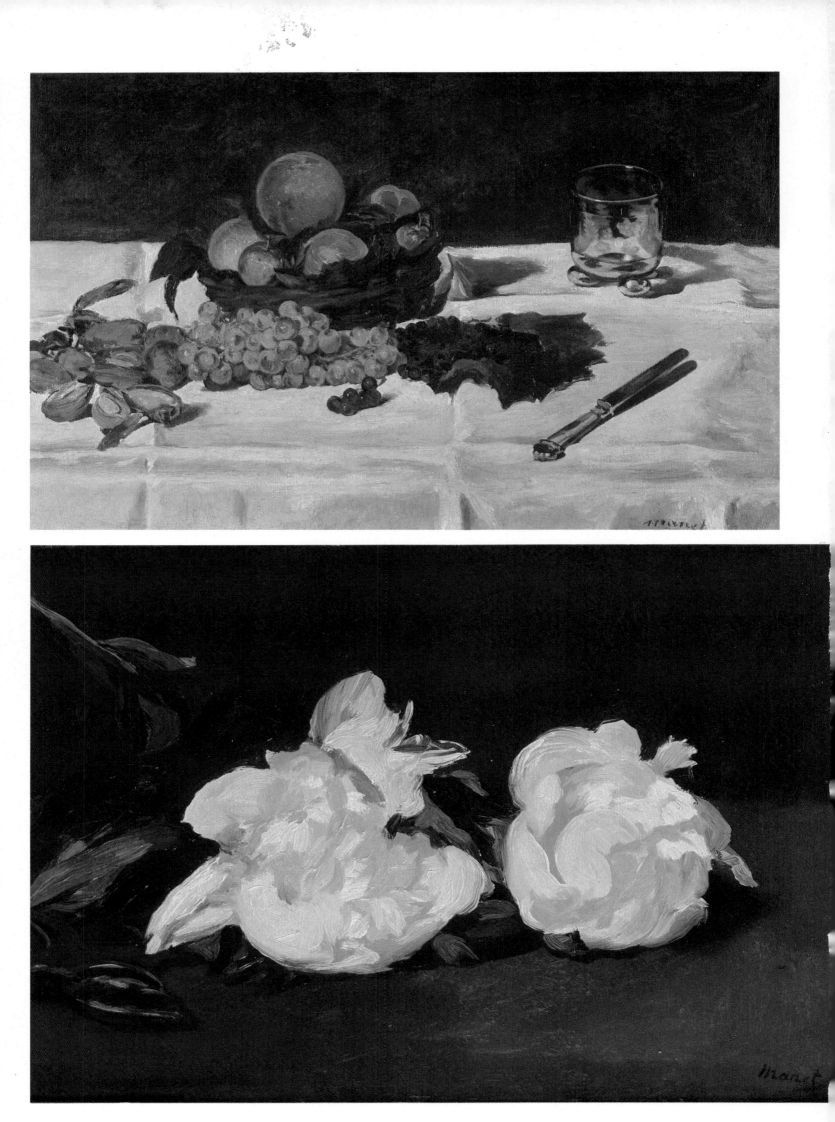

Left: *Fruit on a Table*. 1864. Manet was one of the few 19th-century painters to take still life seriously before Paul Cézanne made it a major pre-occupation of the modern artist. Musée du Louvre, Paris.

who is sitting, brush in hand, at his easel; among those present are Monet, Renoir and Bazille. Degas was to have been included, but he became offended about something or other and insisted on being painted out; his place in the picture is occupied by a statuette and a Chinese bowl on a table. Fantin's painting may have helped to promote the belief that there was a Batignolles 'school' with Manet as its chief, although there is no evidence that the painters worked – rather than talked and drank – together in the 1860s.

'Manet's gang' also had its complement of literary men who were sympathetic towards the new tendencies in painting. One was Zacharie Astruc, an exuberant character who himself dabbled in all the arts. He is shown being painted by Manet in Fantin's *Homage to Manet*, although Manet's surviving portrait of him dates from 1864; like *Olympia*, it is obliquely related to Titian's *Venus of Urbino*, in this instance through the vertical division of the background and the mirror-image figure of Astruc's wife in a domestic setting. Astruc also appears, playing a guitar to a girl, in Manet's *The Music Lesson* (1870). A more melancholy figure at the café was Edmond Duranty, a novelist and critic whose ventures were dogged by bad luck; something of this is captured in the wonderful portrait of him (1870) by Degas, for whom Duranty reserved his greatest admiration.

Still Life with Violets and Fan. 1872. Manet's dedication reads 'Mlle Berthe – E. Manet', the point being that a fan and violets figure prominently in his paintings of Berthe Morisot, notably two (pages 51 and 57) completed in the same year as this still life. Private collection, Paris.

Astruc and Duranty played a significant role as defenders of Manet and his friends, partly replacing the poet Baudelaire, who had died in 1867. There was also Théodore Duret, who had become very friendly with Manet after meeting him in Spain. This cognac-merchant-turned-journalist took several years to appreciate Manet's art, but seems to have been won over by Manet's portrait of him (1868); he was deeply impressed by the spontaneous, quasi-instinctive manner in which Manet worked.

But Manet's most powerful and effective champion was to be the novelist Emile Zola, who embarked on a controversial career as a journalist and art critic with an aggressive article on Manet in the periodical *L'Evénement* (7 May 1866); and a few days later he asserted straightforwardly that 'Manet's place in the Louvre . . . is marked out.' Manet wrote to thank him, and to arrange a meeting 'in order to shake your hand and to tell you how happy I am to be defended by a man of your talent'. Zola soon began to frequent the Café Guerbois, and late in 1867 Manet began a portrait of him that ranks as one of the artist's finest achievements in the genre. Two or three years later Zola figured prominently among the onlookers in the *Homage to Manet*, looking uncharacteristically sleek and successful – like the smooth careerist some have since taken him to have been. But if his articles in *L'Evénement* represented a campaign of publicity-seeking on Zola's part, the results were mixed, since they led to him being

Left: *Still Life with Peonies and Secateurs*. 1864. Musée du Louvre, Paris.

dropped from the paper. However, he persisted, publishing a three-part study of Manet in a magazine, and a little later republishing it as a pamphlet (May 1867) which constituted the first extended analysis of Manet's art. Zola's interpretations have often been challenged on the grounds that they mainly reflected his own literary position as an apostle of Realism (he was soon to proclaim his own version of the doctrine, which he called Naturalism); but if Manet disagreed with anything his friend wrote, he was too discreet – and too grateful for support – to say so. For the rest of his life, he and Zola remained on excellent terms, although privately the novelist seems to have lost something of his enthusiasm for the 'gang's' painting. Manet's delightful *Nana* (1877) seems to have been inspired by his pre-publication information about Zola's courtesan character in the novel of the same name (1880), which caused a literary scandal exceeding even the artistic storm over *Olympia*.

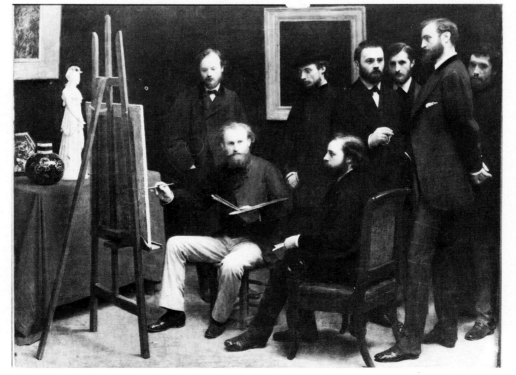

Above: Paul Cézanne. *A Modern Olympia*. 1872–3. An entertaining but obscure comment on Manet's *Olympia* (page 31) by the odd, irascible Cézanne, who seems to have felt a mixture of admiration and envious dislike for Manet. It is not clear whether the joke is supposed to be on Manet or on Cézanne – who distinctly resembled the balding *voyeur* on the couch. Cézanne showed the picture at the first Impressionist exhibition of 1874, where it outraged both public and critics. Musée du Louvre, Paris.

Left: Henri Fantin-Latour. *A Studio in the Batignolles Quarter*. 1870. Also known as *Homage to Manet*, by analogy with Fantin's tribute to an older master, *Homage to Delacroix*. Manet is shown painting his friend Zacharie Astruc. The on-lookers are (left to right) the German painter Otto Scholderer, Auguste Renoir, Emile Zola, Edmond Maître, Frédéric Bazille and Claude Monet. This apotheosis of a painter who was not yet safely dead provoked sarcastic comments from critics and cartoon-ists. Musée du Louvre, Paris.

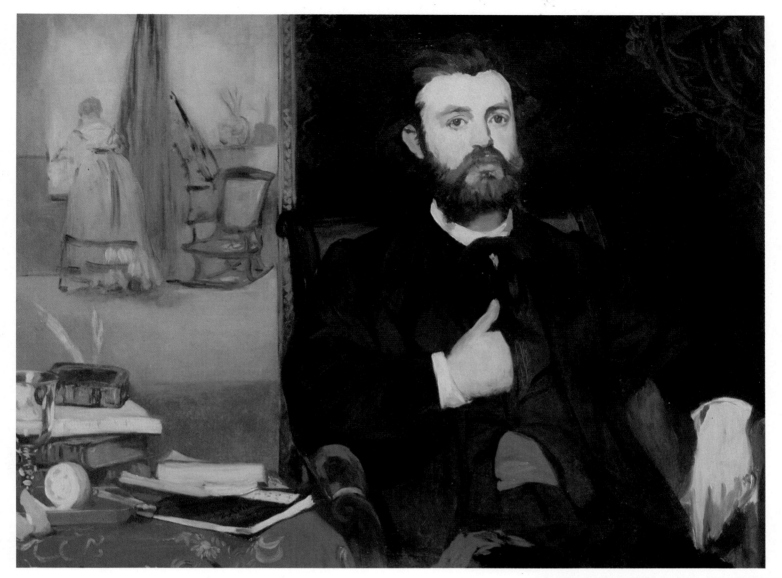

Over the next few years, Manet had need of all the encouragement he could get. In 1866 *The Fifer* and *The Tragic Actor* were rejected by the Salon committee. *The Fifer* is one of his most touchingly beautiful works, in quite another vein from *Olympia*; it might have been painted to demonstrate the sheer range of the artist's sympathies. But the bold outlines and absence of background – acceptable in a 'classic' such as Goya – were seen as unforgiveable breaches of academic convention on the part of a contemporary painter. Deprived of the opportunity to reach the public, Manet held a small private exhibition in his own studio which may have encouraged him to attempt another appeal to a wider audience.

1867 was the year of a Universal Exhibition or World's Fair, held in Paris – one of many grandiose 19th-century celebrations of contemporary progress in industry, science and art, popularized by the Great Exhibition of 1851 at the Crystal Palace in London. Effectively excluded from the Exhibition (he was not allowed to choose which of his works might be shown, and therefore refused to participate), Manet had his own pavilion erected not far from the Exhibition, in a garden adjacent to the Avenue de l'Alma, and put fifty-six of his works on display for the duration of the official show; the price of admission to the pavilion was fifty centimes. Courbet had adopted the same course during the Exhibition of 1855, issuing a fiery manifesto in favour of his version of Realism; Manet issued a catalogue including a preface he had written with Astruc's help – a preface in which, typically, he insisted that he had no intention of protesting about anything or trying to overthrow traditional methods of painting; he had simply tried to be himself. The intolerance was all on the other side; the Salon kept the public from seeing his work, and the public inevitably believed that the Salon's decisions represented the voice of good taste. Since works failing to conform to traditional formulas were not only criticized but provoked active hostility, it was of vital concern that they should reach the general public, for Manet believed that growing familiarity would make them seem less shocking,

Top: *Portrait of Zacharie Astruc*. 1864. The writer Astruc was one of Manet's defenders and helped the artist write an explanatory preface to his exhibition catalogue of 1867. Compare the mirror-image 'background' with that of the *Venus* (page 33). Kunsthalle, Bremen.

Above: Edgar Degas. *Portrait of Edmond Duranty*. 1879. The writer Duranty was one of 'Manet's gang' at the Café Guerbois, although he and Manet quarrelled and fought a duel in 1870. Glasgow Art Gallery, Burrell Collection.

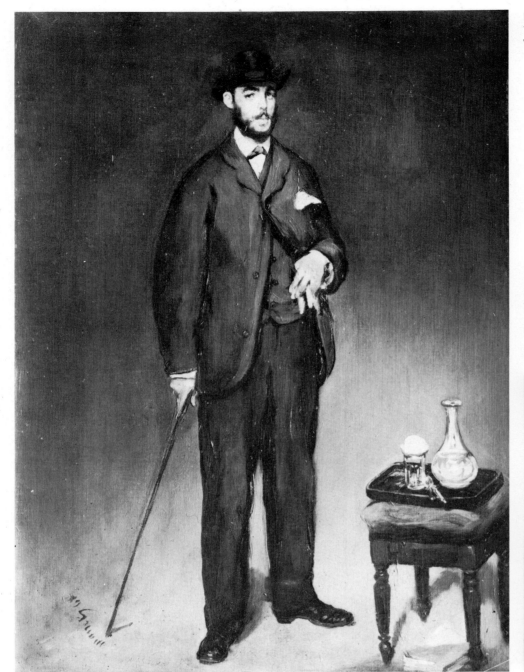

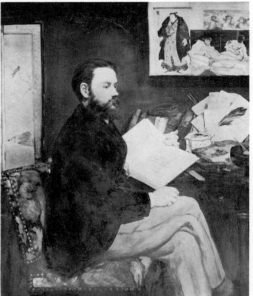

and that they would eventually be understood. His invitation to the public was not 'Come and see some perfect pictures', but 'Come and see some sincere ones'.

Despite this modest and sensible approach, Manet's faith in the public proved unwarranted. Courbet, again exhibiting independently, had something of a success on this occasion, perhaps because Manet's paintings made the older master look the traditionalist that, in many ways, he actually was. Manet launched his show, which included almost all his best – but nevertheless unsold – works, with unaccountable optimism ('I'm going to risk everything, and, supported by men like you [Zola], I am banking on a success.'); but it was a dismal failure with both the public and the critics.

He nevertheless commemorated the event with a charmingly diffuse, naïve-seeming *View of the International Exhibition*. Such public events rarely figure in his work, although in 1864 he had painted the *Battle between the 'Kearsarge' and the 'Alabama'*, a naval duel in the American Civil War that took place just outside Cherbourg; since Manet was staying at Boulogne that summer and the forthcoming battle was widely advertised, it may well be true, as Proust and Duret claimed, that he had himself rowed out of the harbour to get a closer look at the action. Given his youthful experience at sea, Manet's interest in the event is understandable, and the off-centre composition and high horizon of the picture convey the turmoil of action much more effectively than a conventional battle-piece.

The Fifer. 1866. One of the finest paintings in Manet's early style, at once bold, charming and straightforward. The hanging jury of the Salon, accustomed to shading, detail and high finish, rejected it. The subject was a young bandsman lent to Manet by his military friend Commandant Lejosne. Musée du Louvre, Paris.

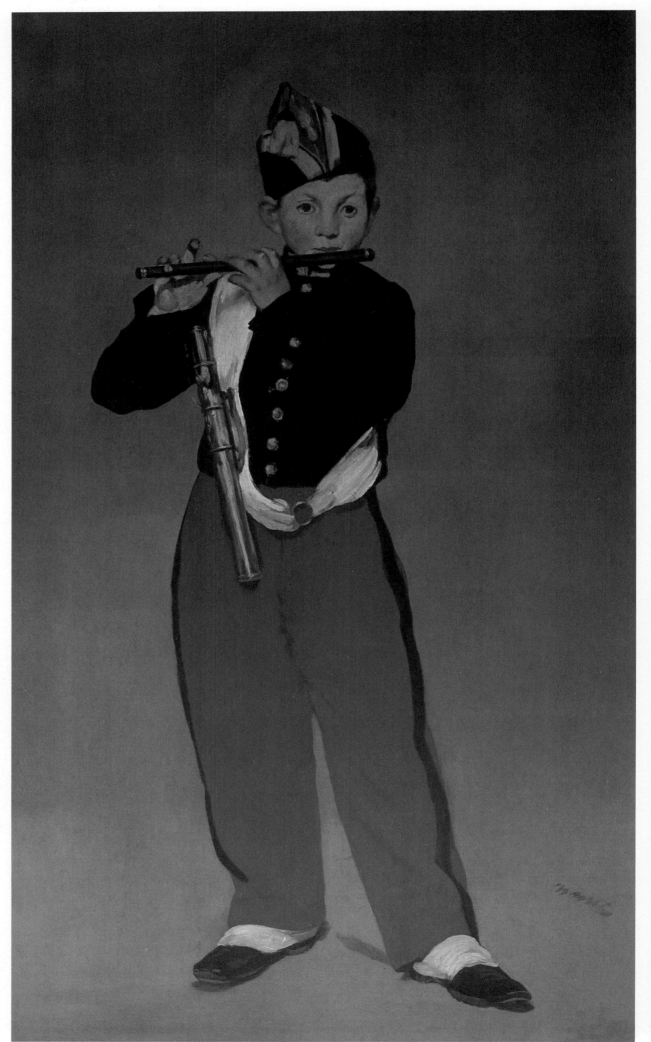

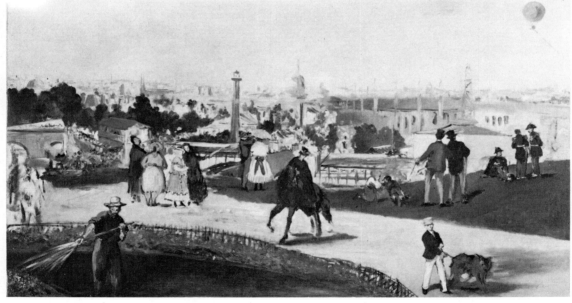

One event of 1867 seized Manet's attention with unusual force: the execution
of Maximilian, Emperor of Mexico. Maximilian was an Austrian archduke who
had been put on the Mexican throne by a French army; but when the United
States ceased to be distracted by civil war and put pressure on the government of
Napoleon III, the French troops were withdrawn and Maximilian was over-
thrown and shot by the troops of the Mexican leader Benito Juárez. Manet
painted the execution four times, and also made a lithograph of it, within a
period of about six months. He made use of such news reports and photo-
graphic materials as were available, for example changing the Mexican-style
dress of the firing squad in his first painting to French-style uniforms in later
versions, done after fuller descriptions of the event had begun to circulate.
In fact, Manet made the uniforms specifically French, a 'mistake' that can
only be accounted for on the supposition that he wished the spectator to

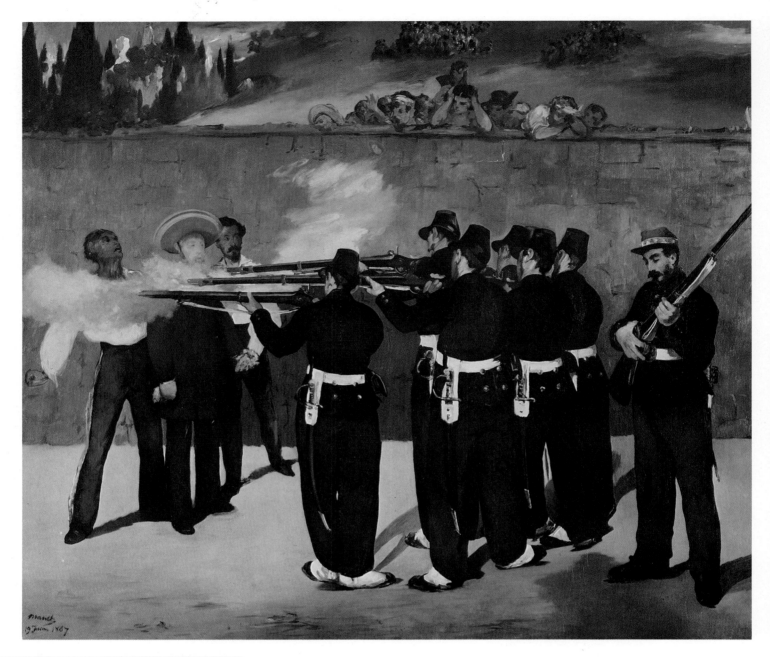

identify French machinations as the real cause of Maximilian's death; this would certainly have been in line with Manet's known anti-Imperialism, and on this issue he would have been expressing a widespread feeling of national guilt and humiliation. The contemporary public would also have recognized the function of the soldier – a sergeant – who stands near the firing squad, checking his rifle: he was to deliver the *coup de grâce* if, as actually happened, the volley of bullets was not instantly fatal. Significantly, the Imperial government took no action against Manet's paintings but forbade the printing of his lithograph – that is, the form in which his work could be reproduced and distributed widely. Manet's desire for authenticity was so strong that he borrowed a squad of real troops from a military friend, Commandant Lejosne; yet in the end it was other values that predominated. In some respects Manet seems to have departed from the known facts for purely pictorial reasons; and, characteristically, he designed the painting so that it related to *The Third of May 1808* by another of his admired Spanish masters, Goya. Manet's *Executions* treat the event in a cooler, more objective style; whereas Goya's painting is a cry of outrage, Manet leaves the spectator to supply his own emotion. Or would we, alive in 1867, have found a message in the sombrero-halo the Emperor is wearing? And would we have spotted the reference to Goya, and reflected that the executions of May the third were also perpetrated by Frenchmen? Those who seek symbols and allusions usually succeed in finding them: the difficulty is to know whether or not they represent the artist's intention, conscious or otherwise. Once again, Manet has denied us any final certainty concerning his work.

Apart from this problematic political episode, Manet's life in the 1860s remained what it had been for some years: at once a painful struggle for artistic

Left: *The Execution of the Emperor Maximilian*. 1867. Maximilian, the Austrian emperor of Mexico, was executed after a popular uprising. Napoleon III had first backed and later deserted him, and as a result many Frenchmen felt disgusted and humiliated by the affair. It evidently preoccupied Manet, who painted no less then four versions of the execution. Stadtische Kunsthalle, Mannheim.

Left and right: *The Execution of the Emperor Maximilian*. 1867. Two of the three surviving fragments from a version of the subject cut up by the painter himself. The soldier who checks his rifle is preparing to give the *coup de grâce* to any condemned man who remains alive after the fusillade. National Gallery, London.

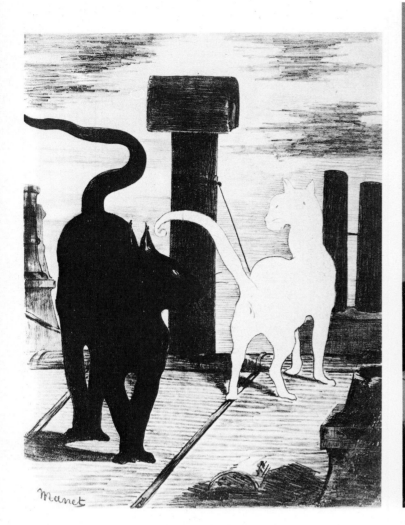

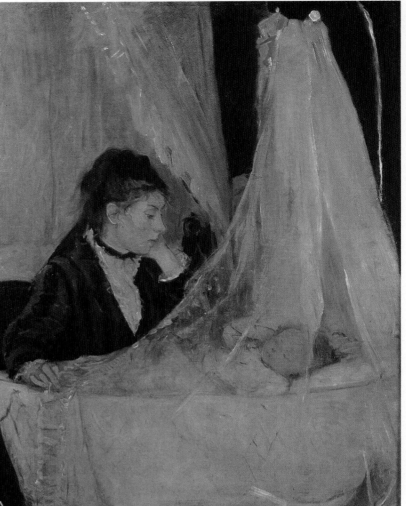

The Cats' Rendez-vous. 1868. A lithograph made for a poster advertising a book by the critic Jules Champfleury. Museum of Fine Arts, Boston, Gift of W. G. R. Allen.

recognition and an easy social existence as a man-about-Paris. In 1868 Fantin-Latour introduced him to the twenty-seven-year-old Berthe Morisot, a gifted painter who had studied under Corot. She and Manet became excellent friends, and she sat for him on four occasions over the following year or so. She appears in *The Balcony* (1868), another painting that relates to Goya, and is shown relaxing on a sofa in *Resting* (1869). Nowadays we should consider her attitude rather graceful, but at the time it was not quite proper for a young woman to sit in public without a straight back – or so, at least, Berthe's parents believed – and therefore the identity of the sitter was kept secret. The incident reveals the enormous gulf between the classes in 19th-century society – between the respectable girl, who must not even slouch, and the other kind of girl, like Victorine Meurend, who might take all her clothes off, and be painted for all the world to see, without the fact causing the least surprise.

As far as is known, Berthe Morisot's relations with Manet were never more than friendly and professional, although she wrote to her sister that 'I certainly find him a most charming man, and he pleases me greatly.' However, this did not prevent her from commenting on his almost comical agitation at the Salon of 1869, where he was painfully torn between hopes and fears; at one moment he despaired of *The Balcony* in the belief that it was a bad picture, at the next he predicted it would have a great success. Evidently Manet's ambitions remained as conventional as ever, and he still failed to see why his work should provide any difficulty for spectators; Morisot noted that he never ceased to be surprised by his failure to please the critics and the general public.

Friendship does not exclude jealousy, of course. Berthe Morisot was not Manet's pupil, but he certainly acted as her artistic mentor (on one occasion he 'retouched' a painting by her so thoroughly – and so little to her taste – that she felt embarrassed about exhibiting it); and when he accepted a beautiful young woman as a pupil, Morisot was not pleased. Eva Gonzalès was in fact the only pupil Manet ever had; she was talented, but unlike Berthe Morisot she failed to achieve a style of her own, independent of Manet's influence. Nevertheless, Morisot complained that 'Manet is trying to improve me and holds up that eternal Mademoiselle Gonzalès as a model.' She was evidently delighted by the

Berthe Morisot. *The Cradle*. 1873. The woman painter Berthe Morisot became a close friend and admirer of Manet in the late 1860s. She exhibited with the Impressionists from 1874, and seems to have been an important link between Manet and the younger generation. Musée du Louvre, Paris.

Right: *Berthe Morisot with a Fan*. 1872. One of many paintings by Manet for which Berthe Morisot acted as the model. Musée du Louvre, Paris.

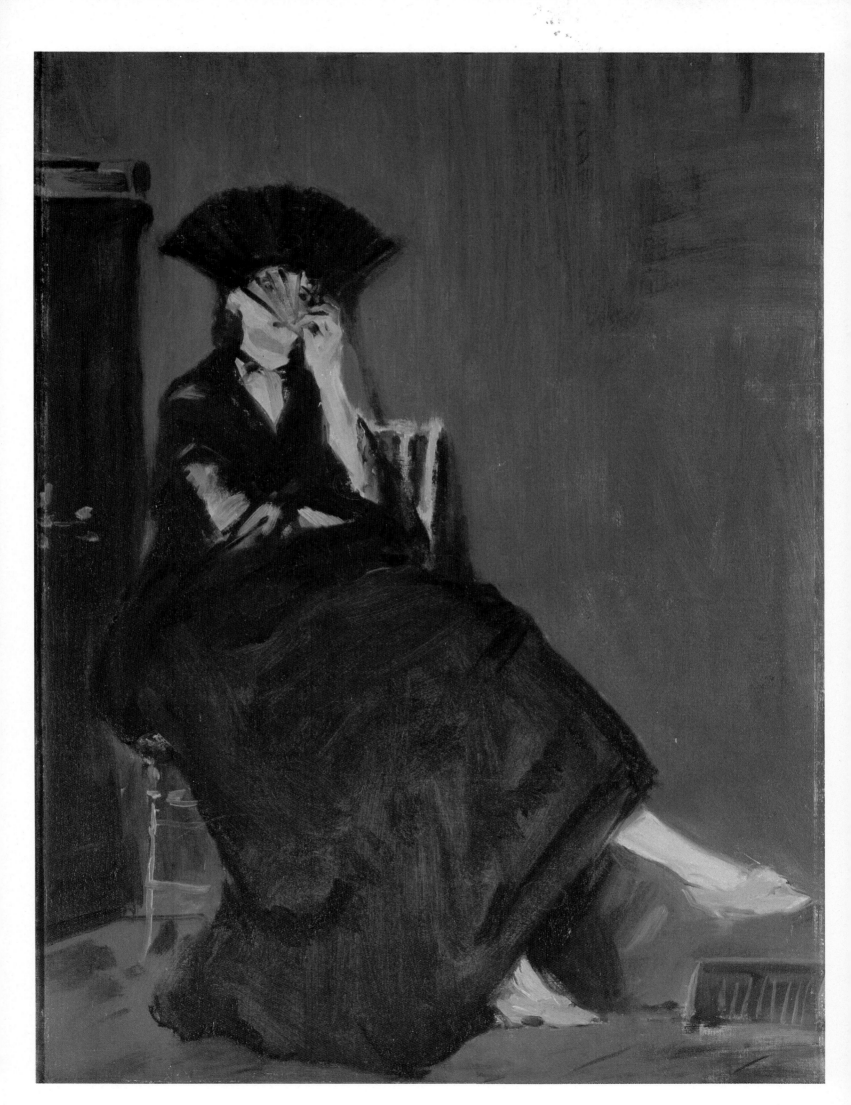

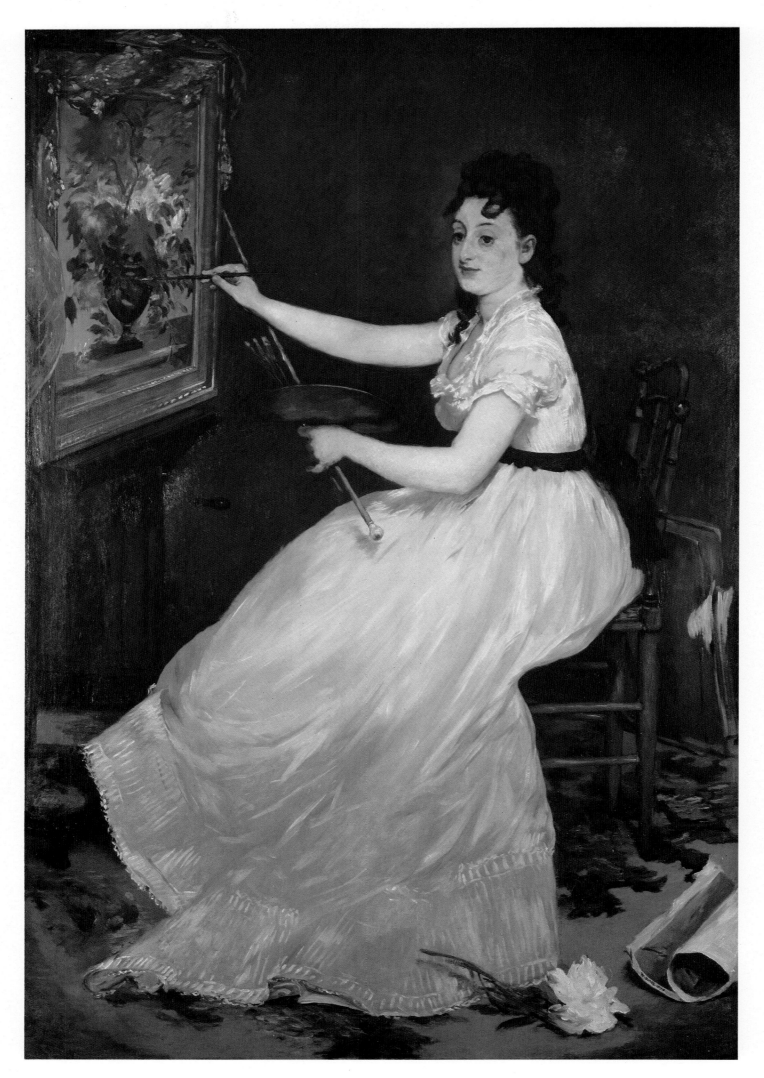

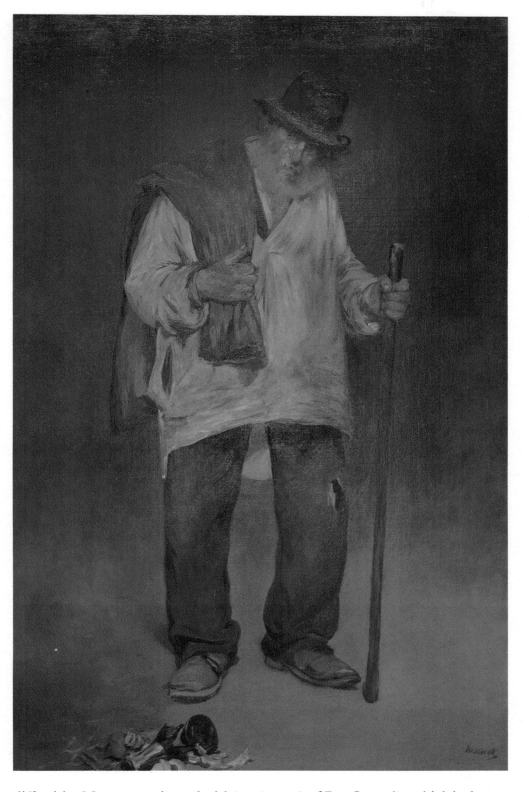

Left: *Portrait of Eva Gonzalès.* 1869–70. Eva Gonzalès was the only pupil Manet ever accepted. His friend Berthe Morisot was rather jealous of her, and took pleasure in the great difficulties Manet experienced with this portrait. National Gallery, London.

Right: *The Rag-picker.* 1869. In a list of his works, Manet grouped this with his much earlier *Absinthe Drinker* (page 17) and two other paintings as 'four philosophers'. Private collection, Geneva.

difficulties Manet experienced with his *Portrait of Eva Gonzalès,* which he began in February 1869 and only finished in March of the following year, just in time for it to be submitted to the 1870 Salon committee. However, when the Manets went to see the Morisots, Berthe was lavishly praised: 'It would appear that my work is decidedly better than Eva Gonzalès's,' she noted with satisfaction.

A more serious rupture between friends occurred when Duranty wrote an article harshly critical of Manet's work. The painter felt sufficiently insulted to box Duranty's ears, and a duel ensued. It took place on 23 February 1870 in the Forest of Saint-Germain; Manet's seconds were two writers, Emile Zola and Vignaux, another Guerbois regular. The affair was evidently more than a formality: there was only one engagement but, according to a statement signed by all four seconds, it was so violent that both swords were damaged. Duranty was slightly wounded (Manet's sword glanced off his rib), honour was satisfied, and the two men quickly resumed cordial relations.

Within a few months a more deadly duel had begun – a duel that proved fatal to the Second Empire.

Manet
and Impressionism

The Barricade. 1871. The savagery of civil war: Manet's lithograph of one of the summary executions of Communards after the troops of the Versailles government had captured Paris. Museum of Fine Arts, Boston, Gift of W. G. Russell Allen.

Far right: *The Barricade.* 1871. This drawing was a preparatory study for the lithograph (above). On the other side of the paper is a drawing of *The Execution of the Emperor Maximilian* which Manet evidently used as the basis for *The Barricade*. Museum of Fine Art, Budapest.

In July 1870 Napoleon III made the mistake of declaring war on Bismarck's Prussia, whose growing strength challenged the traditional predominance of France in continental Europe. The might of the French army proved to be an illusion: badly equipped and poorly led, it collapsed in the face of the Prussian offensive. Defeats and capitulations followed each other in rapid succession, culminating in September with the capture of the Emperor himself at Sedan and the replacement of the Bonapartist régime by the Third Republic. Desperately hoping that a new leader, Léon Gambetta, would succeed in raising new armies in the South, the Parisians prepared to withstand a siege.

Manet evacuated his wife, his mother and Léon Koëlla to Oloron-Sainte-Marie in the far south-west, close to the Spanish border. He remained in Paris as an officer in the National Guard; as luck would have it, his commanding officer was Jean-Louis Meissonier, whose military paintings had made him one of the most popular artists of the day. Berthe Morisot rather cattily described Manet's pleasure in trying on and changing uniforms, and he himself wrote to his wife Suzanne, 'I wish you could see me in my big artillery cloak'; but there seems no doubt that he saw some action, although he naturally made light of it in his letters to Oloron. These, transported from the city by balloon, are our only extended first-hand record of Manet's thoughts – but not, unfortunately, his thoughts about painting. Over the four months of the seige, he described the sorties and repulses, and the Parisians' hopes, disappointments and growing conviction that defeat was inevitable. By December, the weather was freezing, but what coal remained was reserved for cooking. There were no carriages to be seen in the streets; horse-flesh had become a delicacy, and cat, dog and rat butchers had appeared. Gas supplies were exhausted, and by mid-January Manet was summing up life in Paris as 'black bread and gunfire all day and all night'. When the end came, and Paris capitulated, on 28 January, Manet felt relieved that at least he and his brothers – all 'thin as laths' – had survived.

On 12 February, Manet left Paris and made his way to Oloron, after which he spent several weeks recuperating on the coast near Bordeaux. He therefore missed the final act in the tragedy of 1870–71 – the setting up of a revolutionary Commune in Paris, which was again besieged and captured, but this time by government troops while the Prussians looked on indifferently. The Communards resisted desperately, retreating street by street, and the Tuileries Palace, the Hôtel de Ville and many other buildings were destroyed. The government, terrified by the 'red spectre', ordered mass executions and deportations. The street fighting and the shootings were still going on when Manet returned to Paris on 18 May, and he made a number of drawings of the events, culminating in his lithographs *The Barricade* and *Civil War*; characteristically, even these apparent transcriptions of direct experience were related to his earlier *Execution of Maximilian* and *The Dead Bullfighter*.

Among Manet's friends and acquaintances, there were two notable casualties of the war and civil war. Frédéric Bazille, who had volunteered for the Zouaves, was killed in action at the end of 1870, a few days short of his twenty-ninth birthday. And the old rebel, Gustave Courbet, had ruined himself by throwing in his lot with the Commune; as its most famous supporter he had presided over an assembly of artists that had decreed the abolition of the Academic system, and he was held to be chiefly responsible for the demolition of the Vendôme Column, which had been pulled down as a symbol of Bonapartist tyranny and militarism. After the suppression of the Commune, Courbet was imprisoned, his paintings were black-listed, and he was fined so heavily that he fled to Switzerland, where he died in 1877. Interestingly enough, Manet had been elected to the Artists' Federation of the Commune during his absence, which may therefore have been providential in keeping him out of trouble with one side or the other.

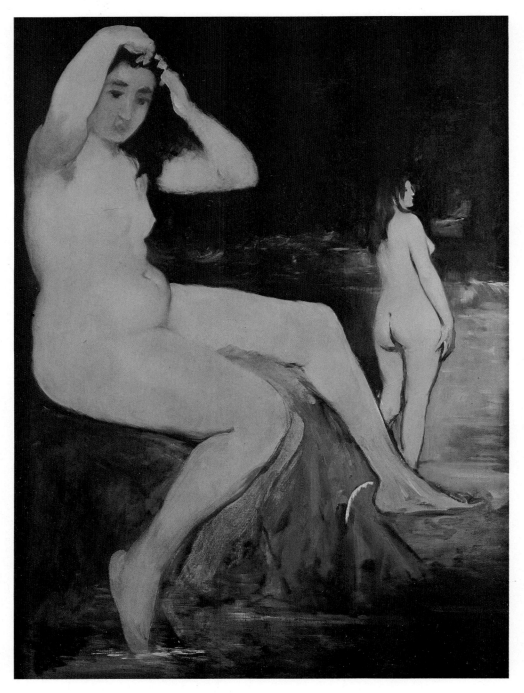

*Bathers in the Seine.
c.* 1875. Museu de
Arte, São Paulo.

Manet's own losses amounted to no more than a damaged studio; his paint-
ings had been put away in a safe place by Duret as soon as the Prussians had
approached Paris. Like the majority of Frenchmen, he picked up the threads of
everyday life remarkably quickly; the ravages of war were made good, and by
1872–73 an economic boom created a cheerful post-war atmosphere. The
prospects of Manet and his painter friends also seemed to be improving, and in
particular they at last acquired their own dealer. The most spectacular result is
entertainingly recounted by Manet's first biographer. One evening the painter
turned up at the Café Guerbois and said to his friends, 'Have the goodness to
tell me who it is you know who can't sell 50,000 francs' worth of pictures in a
year!'

They answered in chorus: 'You!'

Then Manet was able to tell them they were wrong: he had just sold twenty-
odd canvases for 51,000 francs. The buyer was Paul Durand-Ruel, who had
become interested in the paintings of 'Manet's gang' after meeting Monet and
Pissarro in London during the war. Durand-Ruel was the first of the great
modern art dealers – not simply the owner of a shop, like Martinet, but part-
patron and part-entrepreneur, venturing his money to back his taste and to
support and promote promising artists. The existence of such men, and the
consequent multiplication of one-man shows and galleries, played an important
role in eventually breaking the Salon's monopoly of public attention. That,
however, lay in the future: in the 1870s Durand-Ruel was a solitary pioneer, on

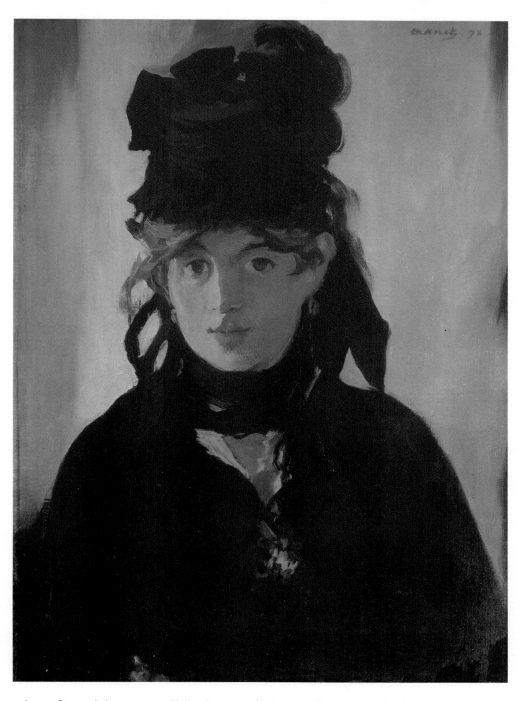

Portrait of Berthe Morisot in a Black Hat, with Violets. 1872. Rouart Collection, Paris.

whose financial acumen all the hopes of Monet, Pissarro and other impecunious painters rested.

Manet seems not to have settled down to work properly until some time in 1872; in order to exhibit at the Salon that year he had to borrow back one of the paintings Durand-Ruel had purchased, the *Battle between the 'Kearsarge' and the 'Alabama'* of 1864. In August 1872 he and Suzanne visited her native Holland, but sometime during the summer he painted no less than four portraits of Berthe Morisot, including the famous portrait of her with a black hat and violets (Rouart Collection, Paris). She was to sit for three more portraits in 1873–74, but after her marriage to his brother Eugène Manet in December 1874 she never sat for him again; whether the fact has any special significance is not clear.

The trip to Holland may have had some influence on *Le Bon Bock* ('Good Beer'), which Manet sent to the Salon of 1873. With its muted tones, Hals-like look and traditional 'Dutch old master' subject – the jolly toper, mug in hand and pipe in mouth – the painting was a great success; it tickled the public fancy so effectively that a *tableau vivant* version was put on at the Château-d'Eau Theatre, and the actor playing the toper anxiously sought Manet's opinion as to its accuracy. The painting may well represent a deliberate concession to public taste on Manet's part, but if so he failed to go on in the same vein: 1873 was also the year of *The Railway*, a painting of enchanting, luminous clarity, and of the daring and exotic *Woman with the Fans*.

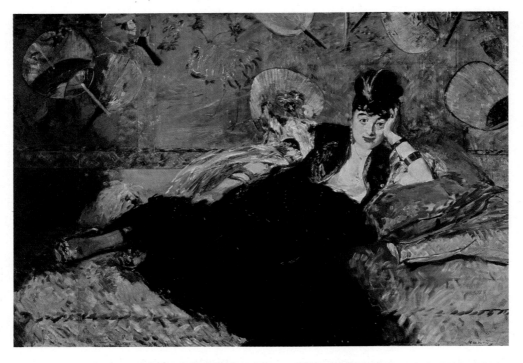

The Woman with
the Fans. 1873/74.
The sitter was Nina
de Callias, a
generous hostess
who cultivated the
society of artists
and writers. The
exotic setting
reflects Manet's
interest in Japanese
art; in combination
with the woman's
casual pose, it also
suggests that she is
not quite respectable.
Musée du Louvre,
Paris.

Claude Monet.
Impression: Sunrise.
1872. This is
generally regarded
as the painting
which gave Im-
pressionism its
name. It was shown
in 1874 at the first
exhibition held by
the 'Anonymous
Society of Painters,
Sculptors, Engravers,
etc.', a group which
Manet had declined
to join. Musée
Marmottan, Paris.

The success of *Le Bon Bock* probably helped to make Manet less than enthusi-
astic when Degas and his other friends proposed to hold an independent group
exhibition; such a gesture – a virtually unprecedented collective stand – could
not be expected to endear the participants to the Academy and the Salon. Nor
was Manet's own experience of a direct appeal to the public – his one-man show
of 1867 – particularly encouraging; and he is reported to have said that 'The
Salon is the real field of battle; these little arenas bore me.' Whatever the
validity of his reasons (or excuses), he declined to lead the 'gang' into battle. And
so the 'Anonymous Society of Painters, Sculptors, Engravers, etc.' was formed
without Manet, and held its first exhibition on 15 April 1874 without any of his
works being shown.

 This event is what we now call the first Impressionist exhibition. The name
'Impressionist' was coined by one of the reviewers, Louis Leroy, who wrote a
long, would-be-amusing article about the various 'impressions' – that is, slap-
happy daubs – on view at the show; he seems to have been inspired by the title
of an exhibit by Claude Monet, *Impression: Sunrise* (1872). Other reviewers
were equally hostile, and the show proved to be scandalous without becoming
successful. Manet's abstention brought him little advantage, since everybody
knew that, present or not, he was the chief of the gang (although most of his

younger friends, now finding their own way, would not have been happy with such a description). Furthermore, *Le Bon Bock* proved a flash in the pan, and Manet had little joy from the Salon for the rest of the 1870s. He nevertheless refused to reverse his initial decision, and did not contribute to the subsequent Impressionist shows of 1876, 1877, 1879, 1880, 1881 and 1882. (The eighth and last show was held in 1886, three years after Manet's death.)

'Impressionism' is not a clear-cut term. Contemporaries used it very loosely, often as a synonym for 'anti-academic', whereas some scholars have adopted a very narrow definition, insisting that even Degas – one of the moving forces behind the exhibitions – was not an Impressionist; as a matter of fact, he himself rejected the label, and had originally advertised the 1874 show to his friends as a 'Realist Salon'. The truth of the matter is that, whatever labels are used, 'Manet's gang' certainly included divergent tendencies. Degas was a 'painter of modern life', concerned to create a sophisticated, thoroughly premeditated, urban (and mainly indoor) art. Monet, Sisley, Pissarro, Cézanne and, to a lesser extent, Berthe Morisot were primarily landscapists, painting out of doors with a rapid spontaneous technique that enabled them to capture the moment, the play of light and atmospheric effects, with a freshness and feeling such as had never been seen before; they were painters of modern life only incidently, insofar as the distinctively modern – a fashionably dressed woman with a parasol, a steam train, a man in the striped T-shirt affected by boating enthusiasts – happened to impinge on the scene.

Was Manet an Impressionist? The answer depends on your definition. His spontaneous technique – the loose brush-strokes, the way in which he risked everything with the beginning of each new painting – was a decisive precedent for the following generation. He even assured the visitors to his 1867 show, in the preface to the catalogue, that 'the painter has thought of nothing but rendering his own impressions'; and one of the objections to his work was that,

Marie Lafebure on Horseback. 1875. Museu de Arte, São Paulo.

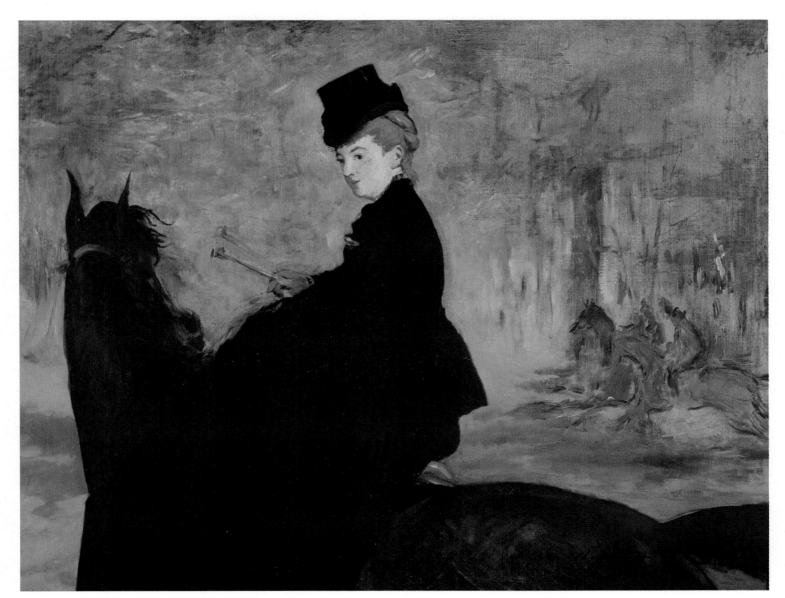

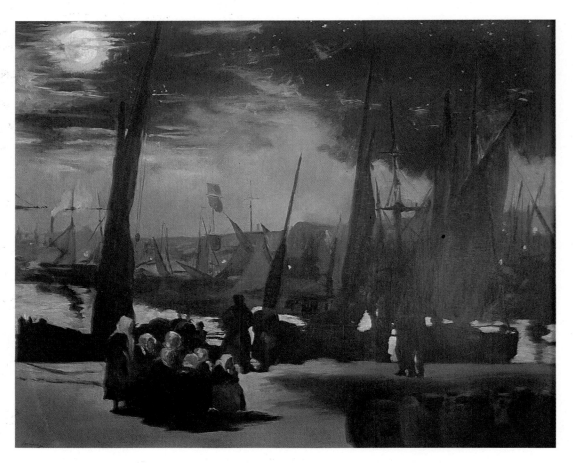

Above: *Boulogne
Harbour by Moon-
light*. 1869. Musée
du Louvre, Paris.

Left: *Petit-
Montrouge in War-
time*. 1870. The sole
surviving canvas by
Manet from the
Franco-Prussian
War period, during
which he served in
the militia. National
Museum of Wales,
Cardiff.

On the beach. 1873. Musée du Louvre, Paris.

like Monet, he left it 'unfinished' – vividly cursory (as it seems to us) or incomprehensibly sketchy (as it seemed to 19th-century critics). On the other hand, Manet was a townsman and an indoor painter, following tradition in that a picture such as *Music in the Tuileries* was painted in the studio from sketches made on the spot. He was not primarily interested in light, and indeed worked with the light behind him, which had the effect of flattening the scene before him to achieve the 'Queen of Spades' look that had so annoyed Courbet in *Olympia*. And it was not Manet but Monet and Renoir who had discovered the distinctive open-air Impressionist technique. Working together in the summer of 1869 at Bougival, a resort outside Paris on the River Seine, they had found that by dappling the canvas with dabs of pure colour, skilfully juxtaposed, they could paint outdoors with the rapidity needed in order to capture 'the moment', and at the same time create a brilliant, vibrant picture surface; close up, it was a meaningless mass of blobs, but when it was seen from a distance, the eye automatically blended the blobs, translating them into a splendidly atmospheric landscape. The normal spectator had been brought up to admire paintings that were smooth-surfaced and executed with invisible brush-work; if, with eye almost pressed against the surface, you still saw the object that had been painted and not a set of coloured marks, the picture was a good one. Given these standards, it is hardly surprising that the Impressionist landscape seemed not merely incompetent but insulting – a joke in bad taste or the wild work of a lunatic or chimpanzee.

Manet had begun to show a belated interest in outdoor scenes at about the time Monet and Renoir were making their breakthrough; his interest may have arisen independently, or possibly through contact with Berthe Morisot. During his regular summer stay at Boulogne in 1869 he painted harbour and beach

scenes for the first time (*Departure of the Folkestone Boat*; *Boulogne Harbour by Moonlight*; *On the Beach at Boulogne*). The sole surviving canvas from Manet's period of war service was *Petit-Montrouge in Wartime* (December 1870), and a few months later he painted a view of Oloron-Sainte-Marie, where his family had taken refuge, followed by more sea views of Bordeaux and Arachon. In 1873, still finding his way, he painted a number of seascapes at Berck-sur-Mer, about thirty kilometres down the coast from Boulogne, introducing a note of drama which, however, seems rather conventional; more successful is *On the Beach*, in which a composition of figures against a background of sand allowed Manet to achieve characteristically sharp tonal contrasts – an effect to be seen far less frequently after the summer of 1874, when his contact with the new outdoor technique was at its closest.

He spent that summer as one of a convivial party in his cousin's house at Gennevilliers, on the Seine opposite Argenteuil, the little town where Monet lived. During the summer, Monet was evicted. Manet helped him to find a new home, and that probably brought about a closer intimacy between the two men. As a result, Manet adopted the new outdoor-painting techniques to a very considerable extent, although he never shared Monet's tendency, already

Monet and his Wife in his Floating Studio. 1874. Painted at Argenteuil, where Monet lived. Manet always admired the younger painter's work, and the two men were particularly close during the summer of 1874. Neue Pinakothek, Munich.

Right: *Argenteuil*. 1874. A large painting, wonderfully evocative of river breezes, sunshine and creaking, restless boats. The man is Rudolph Leenhoff, Manet's brother-in-law. Musée des Beaux-Arts, Tournai.

The Riverside at Argenteuil. 1874. Painted when Manet's interest in outdoor painting, as developed by Monet, Renoir and others, was at its height. Dowager Lady Aberconway Collection, London.

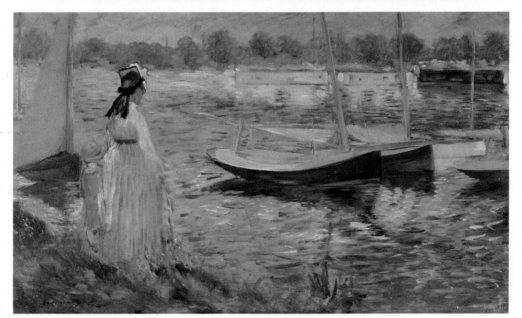

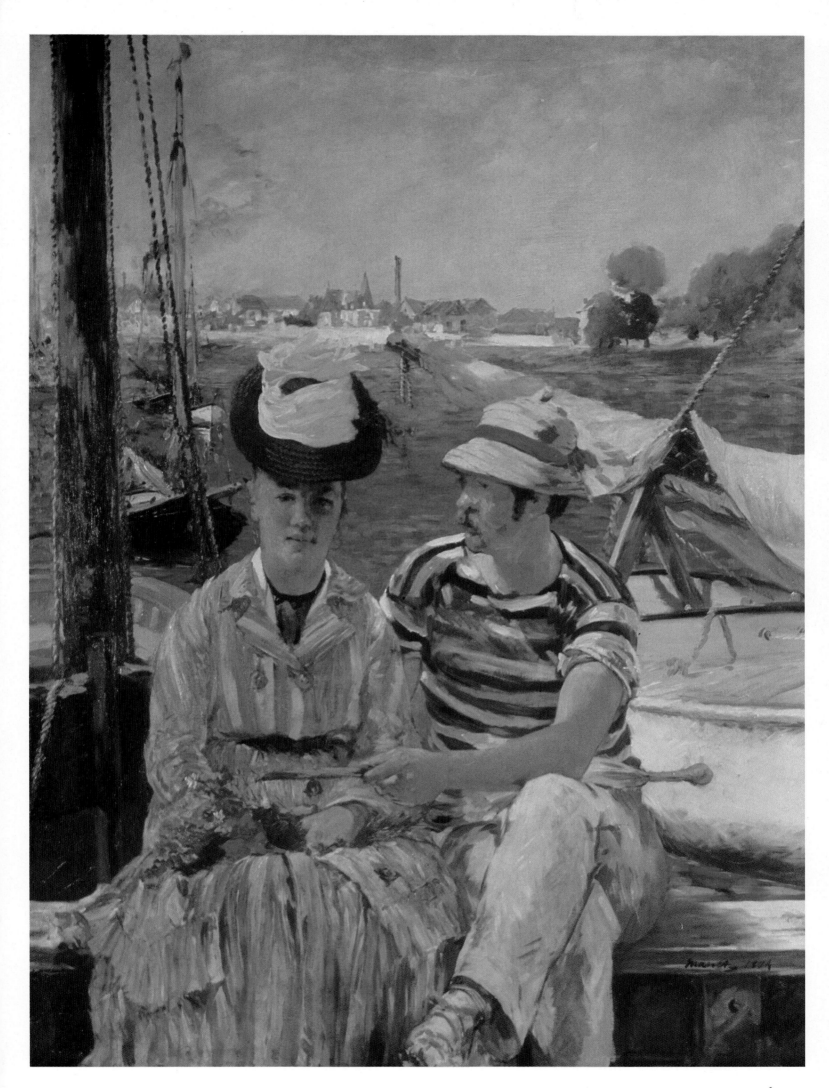

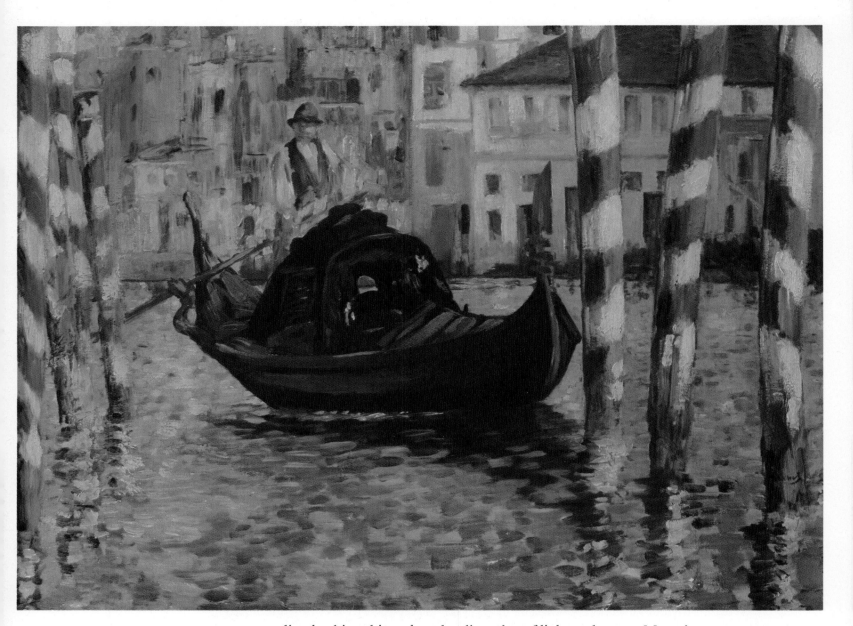

Gondola on the Grand Canal. 1875. After 1874 Manet used the Impressionist technique of outdoor painting only sporadically – as in this picture, executed while on a trip to Venice. Shelburne Museum, Shelburne, Vermont.

apparent, to dissolve his subjects in a dazzling play of light and water. Manet's Argenteuil paintings stake the artist's claim to be one of the major figures of Impressionism in even the narrowest interpretation of the term, bringing his own unmistakable kind of distinction to a favourite Impressionist subject, the gay riverside scene, which was also being interpreted during this period by Monet, Renoir and Sisley. Manet's friendship and esteem for Monet are recorded in *Monet and his Wife in his Floating Studio* and in a delightful scene showing the painter tending his garden while Madame Monet and her infant son rest on the grass. *The Riverside at Argenteuil* is one of the most lyrical of all Impressionist paintings, while *Boating* has the carefree, energetic atmosphere of some Maupassant stories. The most ambitious of all is *Argenteuil*, a large work which Manet dared to send to the Salon of 1875; inevitably, this strong, brilliant painting, with its sensuous feeling for sunshine and river breezes, received a good deal of hostile criticism.

For Manet, unlike most of his friends, the Impressionist open-air technique was simply another weapon in his armoury. He used it later, but only as and when it seemed suitable to him: on a visit to Venice in September 1875, for example, and for such works as *Road Menders in the Rue de Berne* (1878), *The Rue Mosnier Decked with Flags* (1878), *The Girl in the Garden at Bellevue* (1880) and *Singer in a Café-Concert* (1880). However, its influence on him was permanent in the more general sense that his palette remained much lighter than it had been down to the early 1870s, and his brush-work, while not necessarily 'Impressionist', tended to be more 'rough' and unashamedly visible than in the 1860s.

After 1875 Manet turned from harbour, beach and river subjects to the garden, the street and the café. He became, more thoroughly than ever, 'the painter of modern life'.

Right: *Girl in a Garden.* 1880. The setting is a garden at Bellevue, where Manet took the waters in 1879 and 1880, hoping to alleviate or cure his illness. In fact he was already past the help of 19th-century medicine. Private collection.

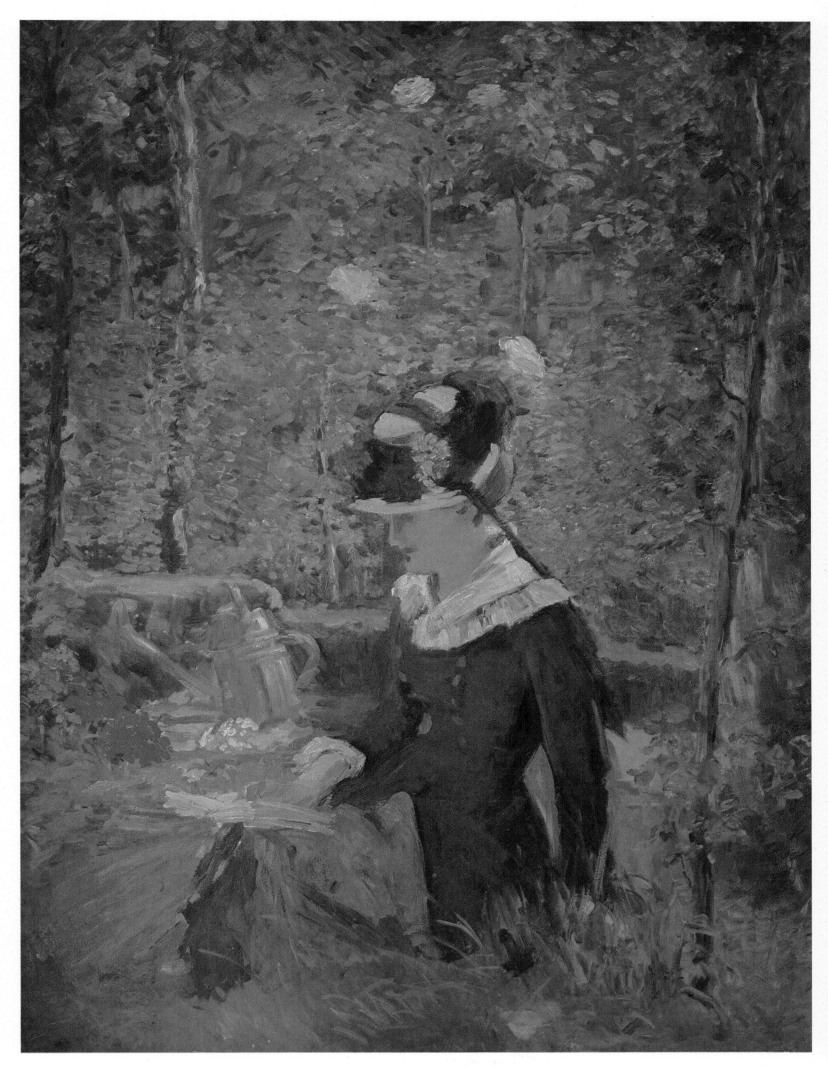

The Painter of Modern Life

The middle years of the decade, from about 1875 to 1877, were a low period for Manet and his friends. The post-war boom had collapsed before the first Impressionist show even opened its doors, and Durand-Ruel found himself in difficulties that made any further acquisitions of Impressionist paintings out of the question. Then, in March 1875, Renoir organized an auction of works by himself, Monet, Sisley and Berthe Morisot at the Hôtel Drouot; the outcome – a near-riot and humiliatingly low prices – showed how far down the Impressionists had sunk in the public's estimation. For years afterwards, the family men among them – Monet, Sisley and Pissarro – had a hard struggle to survive at all; even with the patronage of the rich amateur Impressionist Gustave Caillebotte, Monet was often reduced to sending begging letters to friends such as Manet and Zola. Manet seems to have come to the rescue on several occasions. He himself was fortunate enough to be free from money worries, but the reception of *Argenteuil* at the Salon, followed by the rejection of *The Laundress* and *The Artist* in 1876, seems to have discouraged him, although he did challenge the judgement of the Salon committee by putting the rejected paintings on show to the public in his studio; they recorded their comments, mostly frivolous or derisive, in a visitors' book provided by the artist. As after the similar setback in 1867, Manet produced very little finished work during this period.

His social life, however, remained vigorous, with the usual round of parties and entertainments at home and the intellectual society of his male colleagues in the relaxed atmosphere of the café. By the later 1870s the Guerbois had been replaced by a new rendezvous, the Café de la Nouvelle-Athènes on the Place Pigalle. The younger painters were seen there less often than formerly, since most of them lived outside Paris, which was both cheaper and closer to nature. Degas, 'that round-shouldered man in suit of pepper-and-salt', was still a regular, and there were fresh recruits among literary men. One of the new faces was George Moore, an Irishman who believed himself to be a painter but later turned with greater success to literature. He wrote novels, notably *Esther Waters* (1894), which introduced Zola's type of naturalism to Britain, and memoirs which preserve something of the atmosphere of Manet's circle: 'I did not go to either Oxford or Cambridge, but I went to the Nouvelle-Athènes. What is the Nouvelle-Athènes? . . . the academy of fine arts. Not the official stupidity you read of in the daily papers, but the real French academy, the café.' Moore remembered the friendship and jealousy between Manet and Degas, in his view 'the leaders of the impressionist school', and he also met Camille Pissarro, Jean de Cabaner, an eccentric, impoverished musician of near-genius whose portrait Manet painted (1880), and such writers as Duranty, Paul Alexis and Catulle Mendès. Moore, always slightly ridiculous but easy to put up with, was nicknamed '*l'Anglais de Montmartre*'. He is the subject of Manet's evocative oil sketch *Man Drinking in a Café* (1878), in which he is lying across the table and leaning on one elbow, and of two portraits done about a year later; the better-known is a pastel of extraordinary vigour in which, despite his beard and formal dress, Moore has the wide-eyed look and open mouth of the youthful neophyte, somewhat overawed and perpetually surprised by the doings of the distinguished company he keeps.

Stéphane Mallarmé, one of the greatest – and most esoteric – French poets of the 19th century, became a close friend of Manet's in the 1870s; for long periods of time they seem to have seen each other every day. In 1874 Manet made a set of lithographs for Mallarmé's translation of Edgar Allan Poe's *The Raven*, and Manet's *Portrait of Mallarmé* (1876) is an appropriately elegant canvas which convincingly depicts the poet in a dual role, as man of the world and dreamer of carefully wrought dreams. Given Manet's intuitive approach to his work, the element of sympathy was singularly important to him, especially in portraiture. It was characteristic of him to keep up social relations with people who were

The Singer Faure in 'Hamlet'. 1877. The baritone Jean-Baptiste Faure was a friend and patron of Manet's. All the same, the portrait of the singer in his highly successful role as Hamlet (in the opera by Ambroise Thomas) was beset by difficulties. Faure eventually rejected the painting (now in the Kunsthalle, Hamburg), in spite of which Manet completed a second, more forceful version, shown here. Folkwang Museum, Essen.

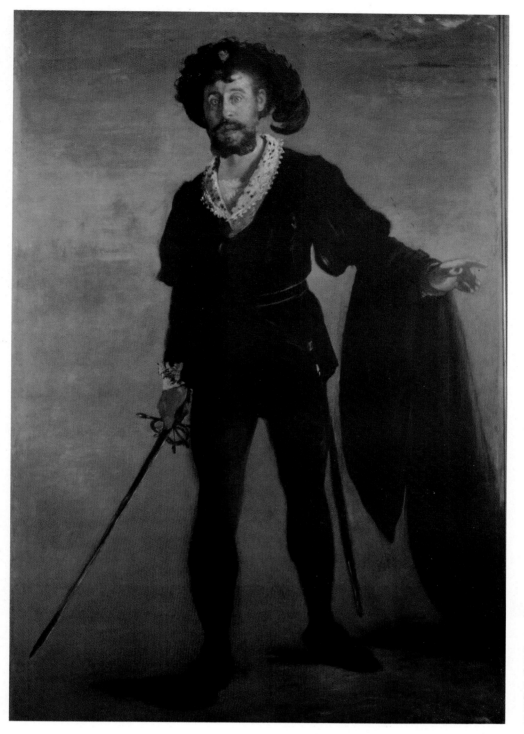

Below: *George Moore in the Café de la Nouvelle-Athènes. c.* 1879. Oil sketch by Manet. Its subject was a young Irish art student who greatly admired him. Moore later turned novelist (*Esther Waters* and *The Brook Kerith*) and wrote reminiscences of Manet and the Impressionists. The Nouvelle-Athènes was the chief meeting place of Manet and his friends during the 1870s. M. Knoedler and Co., New York.

Below: *Portrait of Stéphane Mallarmé.* 1876. The great French poet was one of Manet's intimate friends, and this is one of the most successful of all his portraits. Musée du Louvre, Paris.

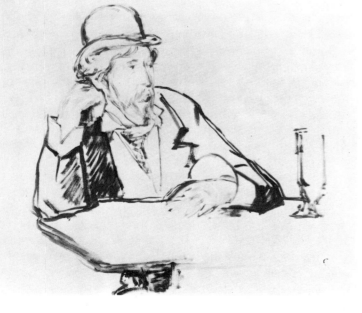

Right: *The Beer Waitress*. 1878–9. Possibly
a fragment of a larger painting. National
Gallery, London.

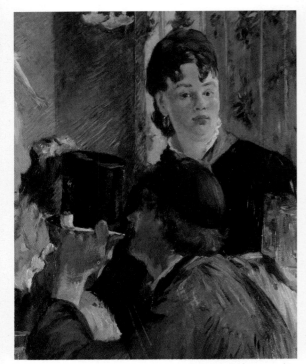

Above: *The Beer Waitress*. 1878–9. A
'close-up' version of the National Gallery
painting of the same subject (above right).
Manet did a number of beer-hall studies at
about this time. Musée du Louvre, Paris.

Far right: *Young Woman with Blue Eyes*.
Musée du Louvre, Paris.

hostile to his art, and he even attempted to paint the critic Albert Wolff, whose
attitude to Manet was (to say the least) ambivalent, while he was downright
hostile to the younger Impressionists – which did not inhibit Manet from asking
him to help them by mentioning the Hôtel Drouot sale in *Le Figaro*. Manet
failed to finish the portrait, in which Wolff never displayed the slightest interest.
One reason put forward to account for Manet's apparently ingratiating attitude
was that he was fascinated by Wolff's extreme ugliness; Degas, stung by one of
the critic's reviews, said, 'How could he understand? He came to Paris by way
of the trees.'

In 1877 Manet painted some of his most delightful 'modern life' works. *Nana*
was a return to the courtesan theme of *Olympia*, but in lighter tones and a lighter
mood, which did not prevent its rejection by the Salon committee. *The Plum*,
showing a young girl sitting at one of the Nouvelle-Athènes' marble-topped
tables, treats a Degas-like subject in a more lyrical style, while *Skating* tackles an
entirely new subject, the ice rink on the Rue Blanche. The moods expressed in
these paintings – indulgent, amused, even tender – carried over into Manet's
works from the years 1878–79; the casual charm of these 'modern life' canvases
is in marked contrast to Degas's unyielding neutrality and incisiveness in
treating similar subjects. During this relatively prolific period, Manet painted
many café scenes in particular; such well-known works as *The Journalist*, *At
the Café*, the pastel *Women Drinking Beer*, *The Beer Waitress* and *Beer Drinkers*
all date from 1878 or early 1879. Also dating from 1878 are a series of nudes in
oils and pastels which look like an attempt to match Degas's studies of women
as female animals rather than as personalities or social beings; this was not
really Manet's forte, and it is not accidental that the most successful of the
series, *The Blonde with Bare Breasts*, is also the most humanized.

The Impressionistic paintings of the Rue Mosnier or Rue de Berne (different names for the same street) were done in the summer of 1878, when Manet was about to change studios and so decided to record the view from his old one in the Rue de Saint-Pétersbourg. *Rue Mosnier Decked with Flags* shows the street on the 30th of June, a national holiday declared to commemorate the International Exhibition of 1878. One version of the subject (Bührle Collection, Zurich), very freely painted, exploits the stir and excitement of moving carriages and breeze-blown flags; in another (Mr. and Mrs. Paul Mellon Collection, National Gallery of Art, Washington, D.C.), the street is almost empty and the one-legged man on his crutches in the foreground contributes to the decidedly ambivalent effect.

Manet's new studio in the Rue d'Amsterdam was not ready until April 1879, and in the meantime he worked in the studio of a friend, Count Otto Rosen. It was a leafy place like a conservatory, and this accident of environment accounts for the special quality of the paintings known as *In the Conservatory* and *Madame Manet in the Conservatory*. Manet exhibited *In the Conservatory* at the Salon of 1879, along with his *Boating* of 1874 – an irresistible combination, one would have thought, but, as so often, public and critical reaction was mixed.

Chez le Père Lathuille (1879) was even less favourably received, although Zola defended it vigorously. Here, in a breathtaking display of Manet's technical and emotional resources, the clarity and fresh, sharp colours of *In the Conservatory* are replaced by a more muted poetry appropriate to a restaurant table beneath the trees. Père Lathuille's was a real place – a restaurant near Manet's old haunt, the Café Guerbois – and the raven-haired, large-eyed young man gazing so soulfully at his companion was Louis Gauthier-Lathuille, the proprietor's son. Nevertheless, the picture succeeds in being at once timely and timeless, an

Left: *The Blonde with Bare Breasts*. 1878. The best-known of a series of nudes executed by Manet during this year. Musée du Louvre, Paris.

Chez le Père Lathuille. 1879. One of Manet's most delightful paintings, sophisticated yet tender in atmosphere. Père Lathuille's was a fashionable restaurant, and the young man in the picture was the proprietor's son. Musée des Beaux-Arts, Tournai.

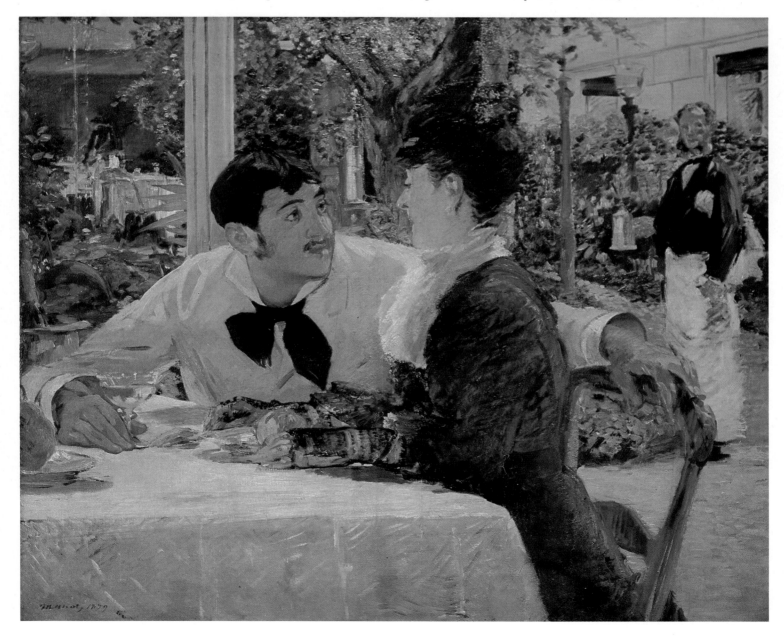

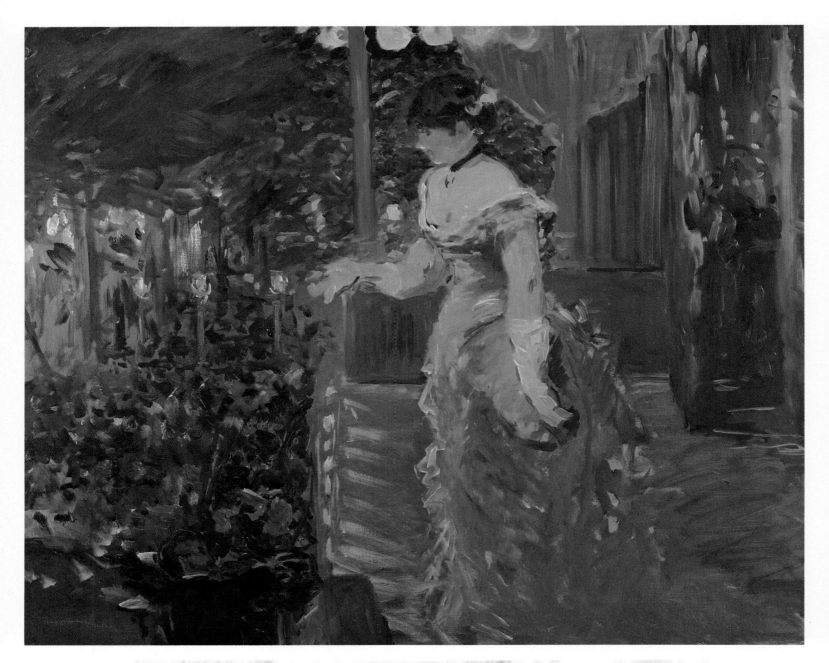

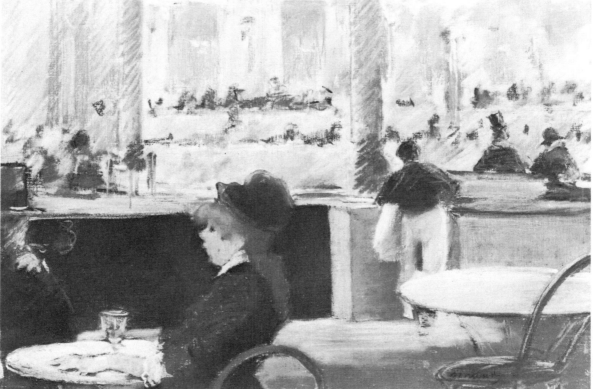

72

Left: *Singer in a Café-Concert*. 1880. Private collection, Paris.

anecdotal moment (seduction? lovers' lies?) and the purest poetry. It has often been proposed as Manet's finest work.

The efflorescence of Manet's art in 1878–79 was overshadowed by the onset of illness. This began with pains in his left foot, originally diagnosed as rheumatism; soon he was limping and began to need a cane for support rather than display. As the pains grew more excruciating and failed to respond to treatment, Manet's doctors realized that he was suffering from locomotor ataxia, a horrible disease of the nervous system that represents one possible manifestation of tertiary syphilis; however, neither its syphilitic origin, nor the fact that it was incurable by contemporary methods, was known at the time. Manet continued to seek treatment, orthodox and otherwise, but he was a doomed man.

The disease sapped his energies, and made it difficult for him to carry through large-scale works. It confined him to his studio in the Rue d'Amsterdam for long periods, and also sent him into miserable exile from Paris for weeks and months – to a medical institute at Bellevue in 1879 and 1880, to Versailles in 1881, to Rueil in 1882. As a result, modern-life scenes virtually disappear from his work – with a few exceptions such as *Singer in a Café-Concert* (1880) and the small pastel *Café in the Place du Théâtre Français* (1881). He had already shown his mastery of pastels; now he made increasing use of them, and also of watercolours, since both media were physically easier to handle and more suitable for the swift execution that a pain-distracted man might wish for. Numerically, Manet's output was still quite large, and certainly larger than in periods of apparent discouragement such as 1868–69 and 1875–77; he produced small still-life studies and flower-pieces, garden scenes done at the villas he hired at Bellevue and other places of 'exile', and portraits – above all, portraits of girls and women by the dozen. As if, ailing, he wished to capture the sweetness of life in its most concentrated form, he sought only charm and sweetness; any one of these little portraits is exquisite, even if as a group they are somewhat cloying.

For them, Manet called on a wide circle of female acquaintances, all elegant but of varying respectability. His favourite models included Méry Laurent, whom George Moore described as a 'tall fair woman like a tearose'. Famous for her many lovers, she was a woman of cultivation who genuinely admired Manet's art and became tenderly attached to him; every year, after his death, she took the first lilac of the season to lay on his grave. Less notorious and no doubt also less perceptive was the nineteen-year-old Isabelle Lemonnier, the sister-in-law of a wealthy publisher and art patron. Her relationship with Manet was probably of the sort from which a middle-aged man expects little and receives even less: he was enchanted by her, painted her six times in 1879 alone, and wrote her many notes from Bellevue which he illustrated with delightful sketches; but there seems to have been little or no response.

Left: *Café in the Place du Théâtre Français*. 1881. Pastel. Burrell Collection, Glasgow Art Gallery.

In the Conservatory. 1879. One of Manet's late masterpieces. The setting was the result of a happy accident — that Manet was forced to borrow a friend's studio, which proved to be a leafy, conservatory-like place. The sitters are Manet's successful painter friend Antoine Guillemet and his wife. Gemäldegalerie, Berlin.

Manet remained ambitious to the last. In April 1879 he wrote to the Prefect of Paris, offering to paint a series of decorations for the municipal council chamber of the new Hôtel de Ville (Town Hall); borrowing a title from Zola, he called the series 'The Belly of Paris' (*Le Ventre de Paris*), and proposed to represent the entire public and commercial life of the city in it, with the addition of a ceiling gallery devoted to outstanding contemporaries. As far as is known, his letter remained unanswered.

For the Salon, 'the real field of battle', Manet painted a very large, relatively conventional portrait of his friend Antonin Proust, which he submitted in 1880 along with *Chez le Père Lathuille*. However, he made a real breakthrough in 1881, when he was awarded a second-class medal for *Pertuiset the Lion-Hunter* and *The Escape of Rochefort*, both painted in the autumn and winter of 1880/81. The award is an example of the perversity of human affairs, since *Pertuiset* was one of Manet's oddest works and *The Escape of Rochefort* was one of the most controversial subjects the painter could have chosen. Rochefort, a radical journalist and Communard, had been transported to New Caledonia but had escaped in a small boat (the subject of Manet's painting) and had been picked up by an English schooner which took him to America. He returned to France after the amnesty of 1880 ('*Vive l'Amnestie!*' scribbled Manet in one of his notes to Isabelle Lemonnier), and his exploits were therefore highly topical. The favour shown to Manet by a predominantly conservative Salon is therefore puzzling, even though its complexion had slightly changed; in 1881 it ceased to be state-run, but the association of artists that took it over was hardly more liberal than the former authorities. The man most responsible for Manet's

Still Life with Salmon. 1860s. Shelburne Museum, Shelburne, Vermont.

Right: *Girl in White.* 1879. The girl is Mlle. Gauthier-Lathuille, daughter of the proprietor of Père Lathuille's restaurant, immortalized by Manet in the painting reproduced on page 71. Musée du Louvre, Paris.

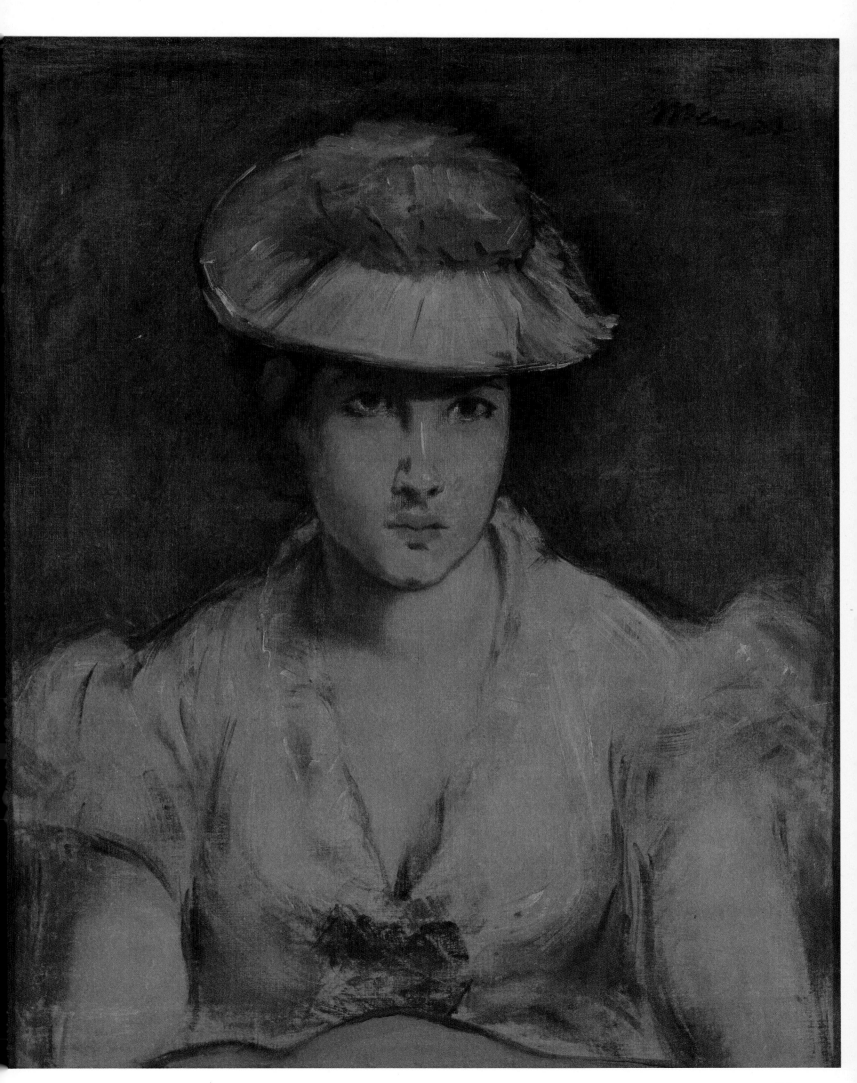

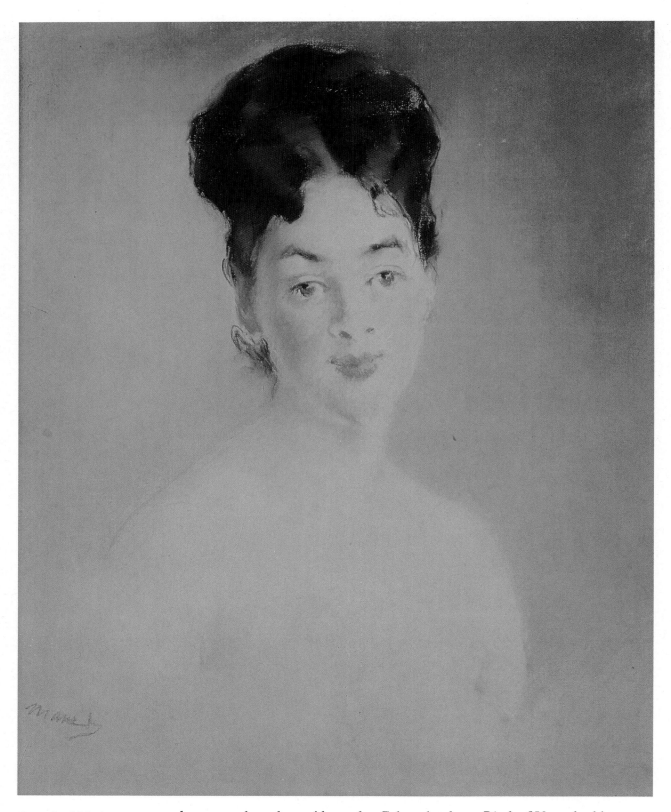

award seems to have been Alexandre Cabanel, whose *Birth of Venus* had been a great Salon triumph almost twenty years before, when *Déjeuner sur l'Herbe* was the scorn of the Refusés. Now, mysteriously, Cabanel exerted his authority in Manet's favour, declaring, 'There aren't four of us here who could do so well!'

In December 1881 Manet achieved another cherished ambition. Léon Gambetta, whom he knew quite well, became premier of France, and Gambetta's Minister of Information was none other than Manet's old friend Antonin Proust. As a result, Manet was named a Chevalier of the Légion d'Honneur, an award coveted by most Frenchmen, since the 'little bit of ribbon' worn in a man's lapel was a discreet but unmistakable advertisement of personal distinction. Despite some bitter comments directed at belated well-wishers, Manet must have felt considerable satisfaction at having finally achieved a measure of conventional recognition.

By this time he was a desperately sick man and, almost inevitably, his temper had become extremely uncertain. But he worked on through 1881–82, and even

Above: *Portrait of Isabelle Lemonnier*. In 1879, already middle-aged and mortally ill, Manet became enchanted by — perhaps fell thoroughly in love with — this young girl. He painted her on a number of occasions and sent her charming letters — without, it appears, evoking much response. Musée du Louvre, Paris.

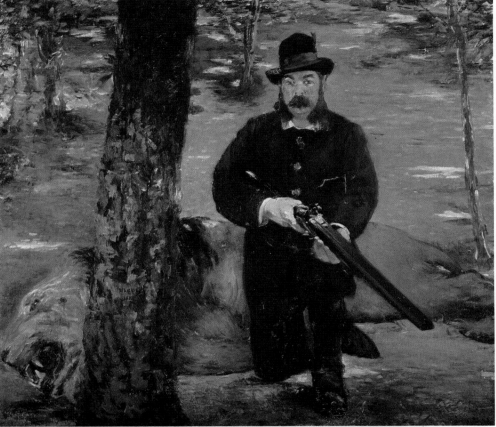

Left: *Pertuiset the Lion-Hunter*. 1880–1. One of Manet's more eccentric efforts. Ironically, it was shown at the Salon of 1881, where he was awarded a medal for the first time in his career. Museu de Arte, São Paulo.

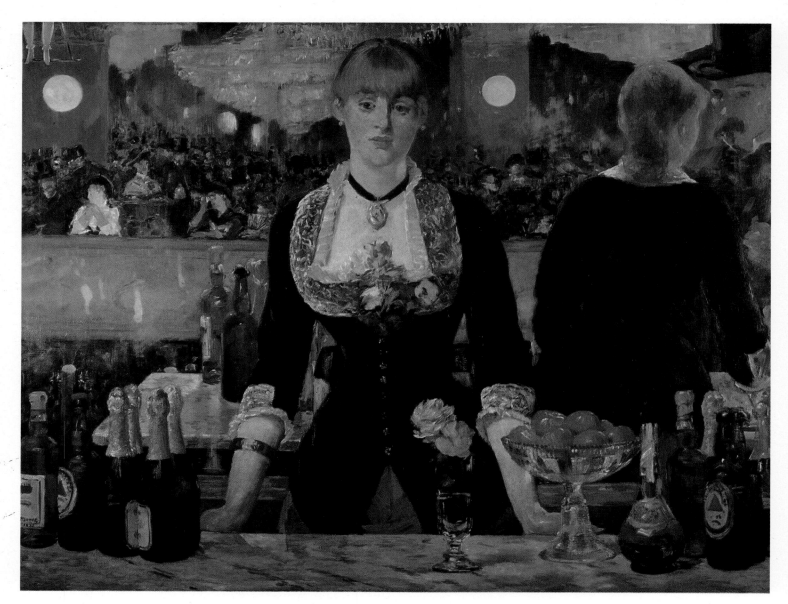

The Bar at the
Folies-Bergères.
1881. Manet's last
large-scale work,
and effectively his
farewell to the con-
temporary scene.
He was already too
ill to stand, and
painted the Folies
barmaid in his
studio, placed
behind a makeshift
'bar'. Nevertheless
the picture has an
extraordinary sense
of immediacy, and
the device of
reflecting the
thronged hall in a
mirror works
brilliantly. Courtauld
Institute Galleries,
London.

found the strength to complete one last large-scale work, *The Bar at the Folies-Bergère*, which was also his farewell to the Salon, where it was put on show in 1882. (As a medallist, Manet was now *hors concours*: his works were accepted automatically.) Manet knew the Folies well, but by this time it was as much as he could do – with many intervals of pain and exhaustion – to execute the painting in his studio; all the same, he strove for as much authenticity as possible, setting up a 'bar' in front of his easel and importing one of the Folies' barmaids to stand behind it. The picture has the enigmatic quality of some of his earlier work (the barmaid's expression is not very different from Olympia's), and most of the 'scene' is simply a reflection in the large mirror behind the barmaid. In view of Manet's condition it is tempting – but probably fanciful – to interpret the painting as elegiac – to see the audience, Paris, as surveying and being surveyed by the artist who served and gave them immortality.

However, it is unlikely that Manet realized how close he was to death; even at the beginning of 1883 he wrote to a miniature painter to arrange for lessons in the technique. His last completed works were flower-pieces, as deftly painted as ever.

During Manet's illness, friends such as Proust and Méry Laurent regularly called or sent to enquire about his progress; towards the end of March, Méry Laurent's maid arrived with flowers for Manet, and he asked her to sit for a pastel portrait which was found on his easel, unfinished, after his death. His left leg had become gangrenous, and on 19 April it was amputated. The expected improvement was short-lived – the disease remained incurable and horribly painful – and on the 30th of April 1883 Manet died.

His work remained controversial after his death – Albert Wolff and his like were unappeased by the posthumous exhibition at the Ecole des Beaux-Arts – and it was not until the early years of the 20th century that Manet took his rightful place among the masters in the Musée du Louvre.

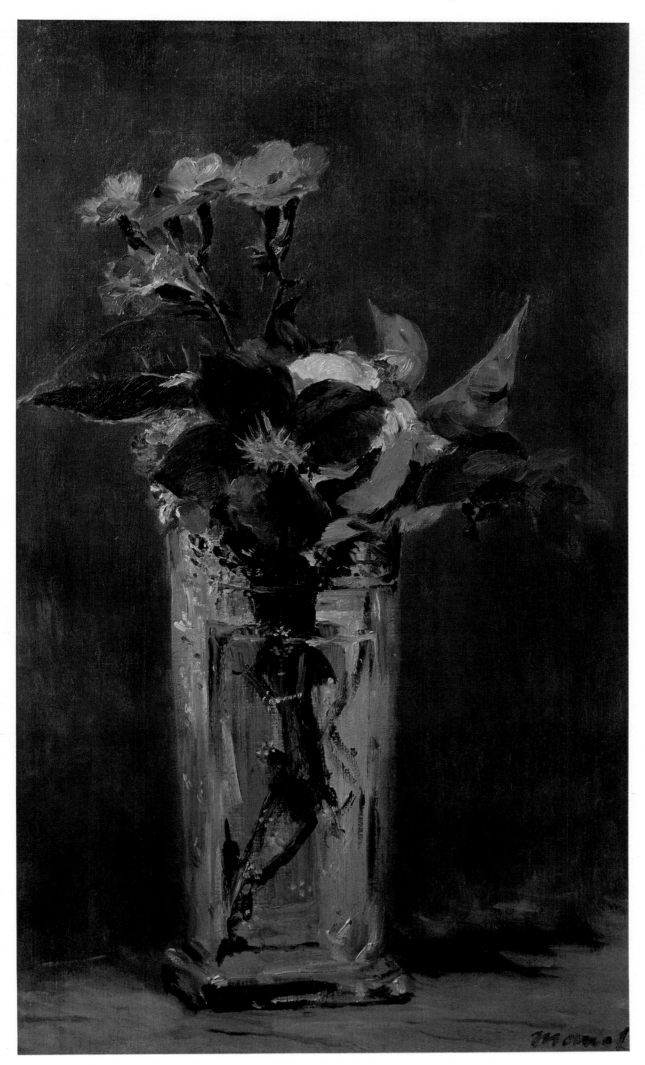

Pinks and Clematis.
1883. Manet's last
completed paintings
were of flowers.
This is the first in
the series. Musée
du Louvre, Paris.

Acknowledgments

Photographs: Alinari, Florence 32 top; Archives Photographiques, Paris 26 left, 39 right, 73; Bayerische Staatsgemäldesammlungen, Munich 27 bottom; Bibliothèque Nationale, Paris 15, 21, 31 bottom left; Joachim Blauel, Munich 62 top; Bridgeman Art Library, London 58 bottom; J. E. Bulloz, Paris 13, 44 left; Courtauld Institute of Art, London 23; Fogg Art Museum, Harvard University, Cambridge, Massachusetts 34; Glasgow Museums & Art Galleries 43 bottom, 72 bottom; Hamlyn Group Picture Library 10, 12, 24 left, 24 right, 31 top, 31 bottom right, 33, 44 right, 46, 48 top, 49, 56, 57, 60 top, 62 bottom, 68 right, 71, 78; M. Knoedler and Co., New York 67 bottom left; Kunsthalle, Bremen 43 top; Kunsthalle, Hamburg 37, Metropolitan Museum of Art, New York 18, 20, 26 right, 36 bottom; Musée des Beaux-Arts, Tournai 63; Musées Nationaux, Paris 8, 11, 14, 19, 25, 28, 29 top, 29 bottom, 30 left, 30 right, 40 top, 40 bottom, 42 bottom, 45, 50 right, 51, 58 top, 61, 67 bottom right, 68 left, 69, 70, 77 top, 79; Museum of Fine Arts, Boston 32 bottom, 50 left, 54; Museum of Fine Art, Budapest 55; Nasjonalgalleriet, Oslo 47 bottom; National Gallery, London 22, 48 bottom, 52; National Museum of Wales, Cardiff 60 bottom; Ny Carlsberg Glyptotek, Copenhagen 17; Philadelphia Museum of Art, Pennsylvania 9, 47 top; Photographie Giraudon, Paris 7, 16, 27 top, 35 left, 35 right, 36 top, 38 right, 39 left, 41, 42 top, 53, 59, 65, 67 top, 72 top, 75, 77 bottom; H. Roger-Viollet, Paris 6, 38 left; Shelburne Museum, Vermont 64, 74; J. Ziolo, Paris 76.

Front cover: *The Beer Waitress*. 1878–9. National Gallery, London. (Hamlyn Group Picture Library)
Back cover: *The Balcony*. 1868–9. Musée du Louvre, Paris. (Hamlyn Group Picture Library)
Endpapers: *Music in the Tuileries*. 1862. Detail. National Gallery, London. (Hamlyn Group Picture Library)
Title spread: *Déjeuner sur l' Herbe*. 1862–3. Detail. Musée du Louvre, Paris. (Hamlyn Group Picture Library)